YALTA 1945

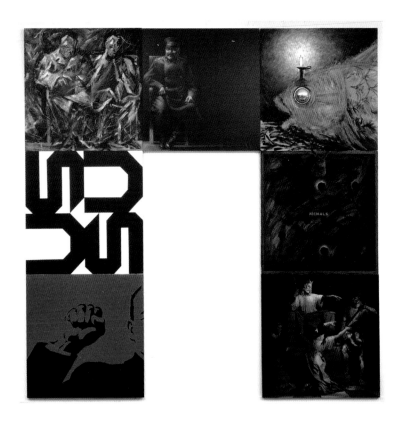
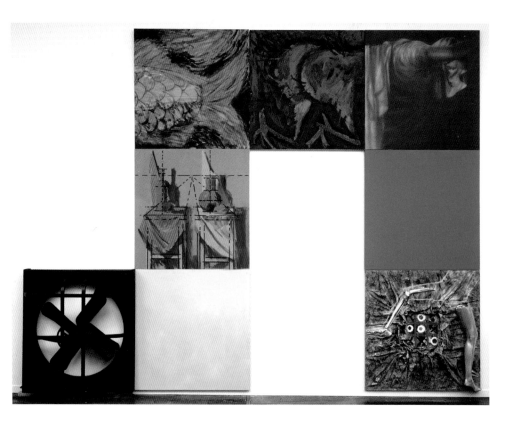

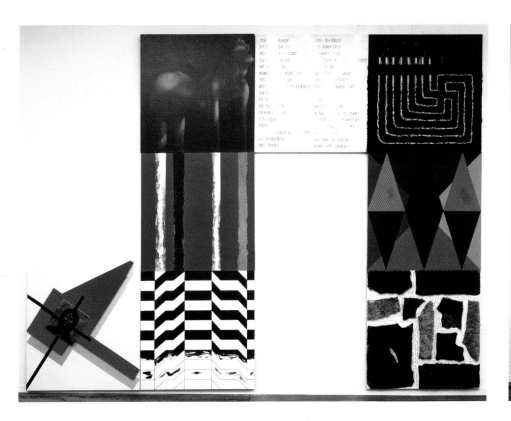

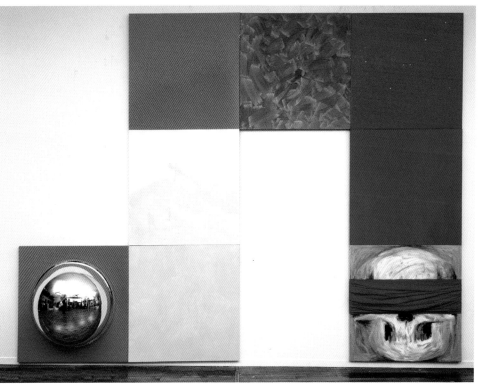

Komar and Melamid

Yalta 1945, 1986-87
(Detail 1A, 2A, 3A and 4A)

mixed media, 31 panels

Photo: D. James Dee

Courtesy of Ronald
Feldman Fine Arts

New York

Vitaly Komar (left) and Alexander Melamid, courtesy of the Former Archive of Komar and Melamid

YALTA 1945

Vitaly Komar and Alexander Melamid

Ben Uri | 100

ART IDENTITY MIGRATION

This publication is designed to bring to a wider international audience both the artwork and the personal risks artists face when using their practice to challenge politically set boundaries, rigorously enforced, to limit and or deny the basic human right of freedom of expression

First published in 2016 to mark the occasion of the exhibition *Yalta 1945* by Vitaly Komar and Alexander Melamid

at
Ben Uri Gallery and Museum
108a Boundary Road
London NW8 0RH

www.benuri.org

British library Cataloguing-in-Publication Data A catalogue record for this book Is available from the British Library.

ISBN 978-0-900157-60-8

Edited and Produced by David Glasser

Copy edited by Rachel Dickson, Katherine Lucas, Maria Ilyevskaya and Kalina Kossowska

Picture research by Katherine Lucas, Maria Ilyevskaya and Kalina Kossowska

Designed by Alan Slingsby, London

Printed by Gomer Press Ltd, Wales

Photography: Our grateful thanks to
The Former Archive of Komar and Melamid;
Ronald Feldman Gallery;
Brooklyn Museum of Art;
Garage, Moscow; Calvert Journal;
documenta archive; UK National Archive;
D. James Dee; Hermann Feldhaus; Adam Gilhespy

Translation: Jeremy Gambrell; Elena Kharitonova; Maria Ilyevskaya; Antonia Misskampf

Copyright: The artists and those detailed

Acknowledgements

Special thanks to

Vitaly Komar for his insight and curatorial support for the exhibition

The owners of *Yalta 1945* for agreeing to Ben Uri's vision of an international tour

Ronald Feldman and Megan Paetzhold of the Ronald Feldman Gallery, New York

Designer Alan Slingsby

Curatorial team Katherine Lucas, Maria Ilyevskaya, and Kalina Kossowska

Gallery team Celeste Heilpern, Cristina Lago and Connor Ward

Learning and Engagement team Katie Harris, Edward Dickenson and Lily Greensmith

Senior Curators Rachel Dickson and Sarah MacDougall for their wise counsel

Contents

Biography of Komar and Melamid

Katherine Lucas and Maria Ilyevskaya

Vitaly Komar

1943 Born Moscow

1977 Immigrated to Israel

1978 Immigrated to USA

Lives in New York

Works in New York

Alexander Melamid

1945 Born Moscow

1977 Immigrated to Israel

1978 Immigrated to USA

Lives in New Jersey

Works in New York

Vitaly Komar and Alexander Melamid are two of the most recognised artists to emerge from the USSR in the late 1960s and early 1970s. In 1972 they founded the controversial *Sots Art*, a movement which fused Russian Socialist Realism with elements of conceptual art, Western Pop Art and Dadaism. 'Sots' is short for 'Socialist'; the movement satirizes the Russian overproduction of ideology, the readily available Soviet propaganda and the official Russian style of Socialist Realism. In their multi-stylistic works of 'conceptual eclecticism', begun in 1972 and developed in *Yalta 1945*, they became inventors of early postmodernism. 'We are not just an artist. We are a movement' they famously declared, never precisely defining the role each played within the creation of any individual artwork. They collaborated together as artists until 2003 when the deeply personal *Three-Day Weekend*, 2004-05 by Vitaly Komar marked the end of their co-authorship.

They both studied at the Moscow Art School: Vitaly Komar from 1956-60 and Alexander Melamid from 1958-62. In the 1960s they both studied at the Stroganov Institute of Art and Design; Vitaly Komar from 1961-67 (he was drafted to the army in 1962-63, where he made Socialist Realism paintings and slogans for the Military Sports Club) and Alexander Melamid from before 1962-67. It was whilst at the Stroganov Institute of Art and Design that they met in 1963, where as part of a requirement to study anatomy in order to be able to accurately draw the human body, they attended an anatomy class in a Moscow morgue at the Institute for Physical Culture. They graduated in 1967, the year in which they held their first joint exhibition, a two-man show entitled *Retrospectivism* at Moscow's Blue Bird Café. It was the norm for 'non-official'

artists in Moscow to exhibit works in private apartments and cafes, as 'official' galleries were not permitted to show such works. In 1968 they joined the Moscow Union of Artists and took up teaching posts.

In 1973 they were expelled from their posts and the Union of Artists as their artistic projects were gaining repute and were considered subversive by the Soviet authorities, as for example they brought the question of overproduction of ideology in the East compared with consumerism in the West into the public domain. They were charged with the 'distortion of Soviet reality and deviation from the principles of socialist realism'. However, they continued to create art that was controversial which resulted in arrest by the KGB during a performance of 'Art Belongs to the People' in 1974. That same year, on the 15 September they exhibited in the controversial *Bulldozer Exhibition*, an outdoor exhibition of unofficial art that was held in a vacant field in Beljaevo, Moscow. It was organised by a Moscow artist, Oscar Rabin, and showcased non-conformist Russian avant-garde artists. Soviet authorities chased the exhibitors and visitors in bulldozers, destroying multiple works of art, including the *Double Self-Portrait* by Komar and Melamid where they are posed in a *faux*-Byzantine style officially reserved for state leaders or decorated heroes, such as Lenin and Stalin. A second outdoor exhibition was promptly organised two weeks later.

After the *Bulldozer Exhibition* Komar and Melamid began to send works to the West and soon received press coverage in the *New York Times* and other international media. The Bulldozer exhibition and the resulting international scandal enabled them, with the help of Melvyn Bernard Nathanson and Aleksandr Goldfarb to be introduced to the New York art dealer Ronald Feldman, who assisted them in organising their first Sots Art exhibition. This took place at his Ronald Feldman Gallery, in New York in 1976, presenting the duo to an American audience who saw the work as fresh and understood how controversial such work would be in the Soviet Union. The art shown had to be literally smuggled into the USA. They were banned from visiting the exhibition by the Soviet authorities but eventually were granted exit visas, moving first to Israel in 1977, and then to New York in 1978. Through growing public personas they became known as iconic Soviet émigrés. They were the first Russian artists

to receive a grant from the American National Endowment for the Arts in 1982 and to be invited to participate at the *documenta* exhibition at Kassel, Germany in 1987. They created and exhibited two installations at *documenta 8 – Yalta 1945* and *Winter in Moscow 1977*.

They fully exploited their new found Intellectual and creative freedom in the United States. During the 1980s and 1990s, their repertoire expanded to include conceptual projects involving music, monumental sculpture, performance and even teaching elephants in Thailand to paint, often accompanied by publications to disseminate their ideas. They collaborated with other artists across many mediums, including Douglas Davis, Charlotte Moorman, Dave Soldier, Andy Warhol and many like minded Soviet artists, through interventions with their defunct monuments on *Monumental Propaganda* in 1993 (travelling show, Independent Curators, 2003); the masses and Marttila & Kiley Poll Company on *Most Wanted and Most Unwanted Paintings* in 1994; composer Dave Soldier on an opera about Washington, Lenin and Duchamp, *Naked Revolution* in 1997 (Walker Art Centre, Minneapolis and The Kitchen, New York); painter Renee the elephant in 1995 and with photographer Mikki the chimpanzee in 1998 (Russian Pavilion at the Venice Biennale, 1999). Their works continued to re-appropriate and subvert the ideological aesthetics of the Soviet Union. They worked on artistic projects based around iconoclasm, democracy and religion. Their art illuminates the isolated and dichotomous life of an émigré, stuck somewhere between nostalgia for a Communist past and a Capitalist present.

Their extraordinary creative partnership came to a close in 2003 and they continue to work separately on a wide range of projects.

See http://www.komarandmelamid.org.

Sources:

- Andreeva, E (1995) *Sots-Art: Soviet Artists of the 1970s and 1980s*. Roseville East, Australia: Craftsman House
- Nathanson, M (1979) *Komar/Melamid: Two Soviet Dissident Artists*, Southern Illinois University Press Carbondale and Edwardsville Feffer & Simons, Inc
- Radcliffe, D (1989) *Komar and Melamid*, New York: Abbeville Press
- Weinstein, A (ed.) (2005) *Vitaly Komar: Three-Day Weekend*. New York, The Humanities Gallery The Cooper Union for the Advancement of Science and Art
- Tupitsyn, M (1986) *Sots-Art*. New York, The New Museum of Contemporary Art
- Wollen, P (1985) 'History Painting' in Wollen, P and Francis, M (1985) Komar and Melamid. The Fruitmarket Gallery, 1985.
- Komar and Melamid, Ronald Feldman Fine Arts (2016), www.feldmangallery.com/pages/home_frame.html
- Komar and Melamid (2016), www.komarandmelamid.org

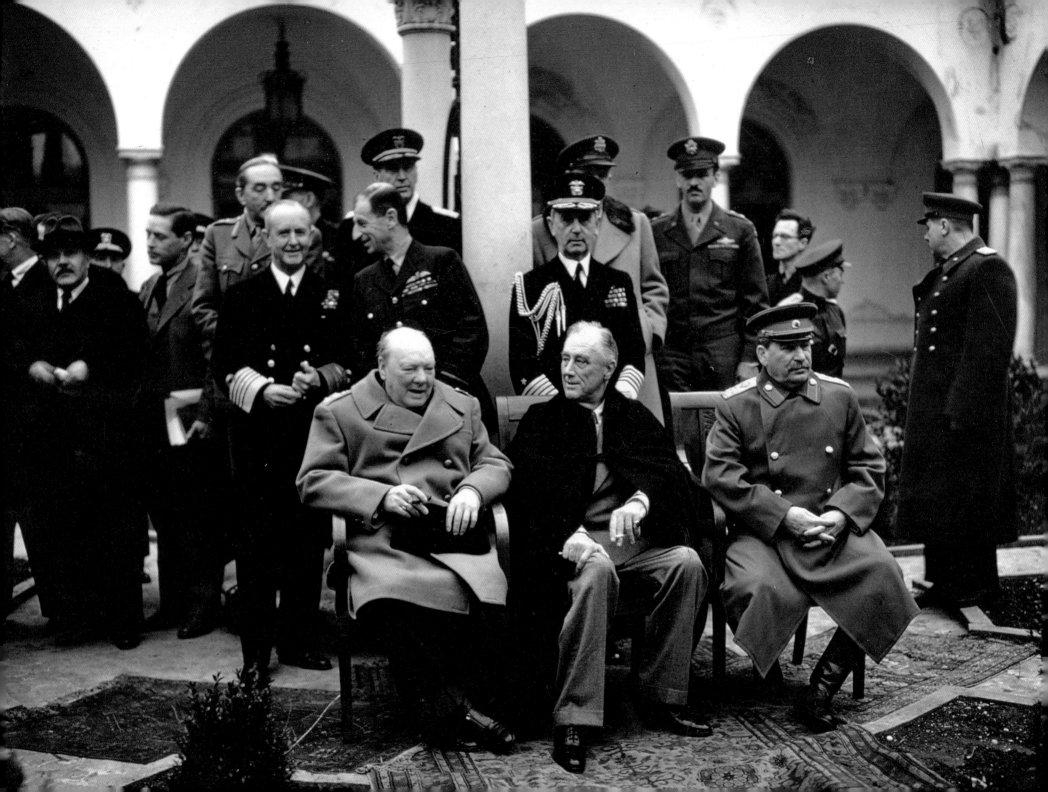

Yalta Declaration on Liberated Europe

1. **The Defeat of Germany.** This section essentially stated that the three major Allies would continue fighting Germany until they won.

2. **The Occupation and Control of Germany.** Section 2 started with a statement of the decision to demand unconditional surrender. From there it went on to note the creation of four occupation zones for the Americans, British, Soviets, and French, but naturally gave no indications of the exact boundaries involved.

3. **Reparation by Germany.** This section simply stated the Allies would extract unspecified war reparation from the defeated Reich.

4. **United Nations Conference.** The Big Three noted their intention to found the United Nations as soon as possible, with a conference on the subject scheduled for San Francisco, California on April 25th.

5. **Declaration of Liberated Europe.** This section gave lengthy but very general descriptions of how the Allies would restore the right to self-determination to Europe's nations, in accordance with the Atlantic Charter.

6. **Poland.** The sixth item stated that the Polish Provisional Government of National Unity would be formed via free elections but did not specify when these would occur.

7. **Yugoslavia.** The Big Three agreed Marshal Tito would create a government in Yugoslavia, on an allegedly temporary basis but with no indication when a democratic government would be established.

8. **Meetings of Foreign Secretaries.** This section suggested Stettinius, Eden, and Molotov might continue meeting every quarter to continue friendly coordination between their government.

9. **Unity for Peace as for War.** The three leaders pledged to cooperate in peacetime as well as during the remainder of World War II.

Yalta Conference, Churchill
Roosevelt Stalin

February 1945

The National Archives UK

As printed in *The Yalta Conference: The History of the Allied Meeting that Shaped the Fate of Europe After World War II*.
(Charles River Editors, 2016)

History of the Yalta Conference: February 4 –11, 1945

Between 1941-46, the 'Big Three' powers of the West and the East, as represented by the heads of governments of the United States, United Kingdom and Soviet Union: U.S. President Franklin D. Roosevelt, British Prime Minister Winston Churchill, and Soviet Premier Joseph Stalin, had a string of meetings and three summit conferences:

1) Tehran, Iran, in 1943 (strategy orientated)
2) Yalta, Russia, in February 1945
3) Potsdam, Germany, in July 1945 (practical post-war arrangements)

Yalta, the second of the three conferences and codenamed the 'Argonaut Conference', occurred just before the end of the Second World War, between February 4-11, 1945. It was where Roosevelt, Churchill and Stalin made important agreements regarding the imminent end of the war, and the future of post-war Europe and the world. It was 'initially portrayed as a great success … [however] within weeks, exhibited to the world as a failure'.[1] It has since been the subject of great controversy. Some discussions about the division of Europe, although not in any way formalised, had occurred or were agreed on during a previous meeting between Churchill and Stalin, which took place in Moscow in October 1944. However, this was without US involvement, and many questions remained unanswered or were avoided completely, particularly issues concerning Poland and Germany.

The second conference was held in the Crimean town of Yalta, a remote setting in the Black Sea, a location chosen after Stalin had declined the previous two options of northern Scotland or the Mediterranean, due to poor health and a fear of flying. Yalta had been the summer home of the Tsars; however, due to the war, it was now in ruins except for the few palaces that were restored by the Russians especially for the conference. Churchill had commented, 'We could not have found a worse place for this meeting if we had spent ten years looking for it',[2] and getting there was not straightforward: Roosevelt travelled by sea to Malta, then took a flight to Simferapol, followed by an eight-hour drive over mountain roads to Yalta. A plane carrying British delegates crashed en-route. The conference finally convened at the Livadia Palace, President Roosevelt's residence for the duration – he was suffering from ill-health – where discussions were conducted in complete secrecy. Following the conference, Roosevelt returned to the United States; however, on 12 April 1945, he suffered a massive fatal stroke and was unable to participate in the Potsdam Conference. Harry S. Truman, his successor, attended in his place.

Discussions focussed on the military situation – briefing each other on plans regarding the Eastern front; the fate of Germany, including three important factors: the role of France, war reparations and the country's division – the 'Dismemberment of Germany'; United Nations voting rights – believing that it should be the larger powers (Russia, United States and Britain) that governed, with smaller countries only being able to offer opinions; issues surrounding the reshaping of Poland and free elections, and negations in Eastern Europe. They called for Germany's unconditional surrender and set about deciding on the zones of Allied occupation and the split of Berlin. The French were allowed some areas of occupation within Germany; however, this was to be taken from the American and British zones, leaving the Soviets with their scope of territory and power in Germany undiminished.

These agreements were formed into the 'Declaration on Liberated Europe', which was signed by the Big Three in alphabetical order. However, neither the Soviets nor the British properly understood or were prepared to take seriously the expansive democratic promises as stated – highly likely due to the fact that all three had struggled to agree on all parts, other than the formation of the United Nations – which explains the stark contrast between what was decided and what was actually implemented afterwards. A further document, the 'Protocol of the Proceedings of the Crimea Conference' was also published; however, although this went into more detail, final decisions were left to future conferences. It is this lack of understanding and lack of finality in decision-making – thus leaving the future of Europe still rather unresolved – which

1 Harbutt, Fraser J, *Yalta 1945 Europe and America at the Crossroads*, (New York: Cambridge University Press, 2010), p.3

2 Harbutt, Fraser J, *Yalta 1945 Europe and America at the Crossroads*, (New York: Cambridge University Press, 2010), p.280

created the origins of the move away from unity towards the subsequent position of Cold War hostility.

The Yalta conference is described as lying at 'the heart of the conventional East/West view',[3] where both sides – West and East – often had contrasting political agendas, but nonetheless, in order to succeed, they needed each other's cooperation. For example, for agreement on the United Nations, Roosevelt needed to accept Soviet hegemony in Poland and Eastern Europe. There was also a contrast in the East/West response following the conference. To the East, Yalta was portrayed initially as a great success and a 'magnificent declaration';[4] however, in the West, it was a diplomatic disaster which exemplified the nature of Stalin's dictatorship – always aiming to win, and always calculating, in order to achieve his goals – with the West conceding the Curzon Line and governmental issues in Poland, accepting the revised Lublin regime that would hold unsupervised elections. It can be seen as a symbol of growing Soviet power, with the West failing to anticipate the Soviet Union's concerns, meaning that Stalin emerged from the conference with the most territories and successful agenda, compared with Churchill and Roosevelt's relative failure. Roosevelt's only success was the agreement of the United Nations voting rights.

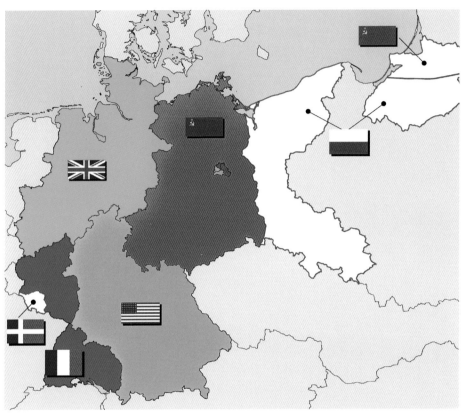

Division of Germany between United Kingdom, United States, France and Russia following the Yalta Conference

3 Harbutt, Fraser J, *Yalta 1945 Europe and America at the Crossroads*, (New York: Cambridge University Press, 2010), p.x

4 A 1975 recollection by an aging Molotov that provides authoritative Soviet evidence on the Soviet motives: Resis (e.d), *Molotov Remembers*, p.51, as cited in Harbutt, Fraser J, *Yalta 1945 Europe and America at the Crossroads*, (New York: Cambridge University Press, 2010), p.320

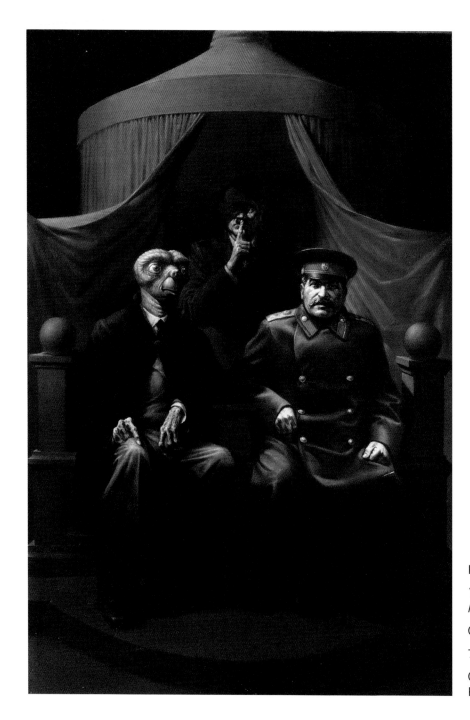

Komar and Melamid

Yalta Conference (From a History Book, 1984), 1982

Oil on canvas

72 x 50 inches

Courtesy of Ronald Feldman Fine Arts, New York

Yalta Conference Series
by Komar and Melamid

Katherine Lucas and Kalina Kossowska

Yalta 1945 from 1986-1987 is not the only work in which Vitaly Komar and Alexander Melamid have referenced the Yalta Conference and its participants. They speak of Yalta 'as the mating of superpowers whose offspring is the postwar world, a place where American and Soviet symbols of power are interchangeable' (Radcliff, 1988, p.135). As Vitaly Komar mentions in his interview with David Glasser, this work forms part of a group that reference the 'Yalta Conference' either in individual works or as part of a series:

Yalta Conference (From a History Textbook, 1984), 1982
The Minotaur as a Participant in the Yalta Conference. 1984-85 (from Diary series)
50 Public Mural Projects for the United Nations Building in New York, 1987-95

In *Yalta Conference (From a History Textbook, 1984)*, 1982 Roosevelt (painted as E.T, an invention of American pop culture) and Stalin are shown in ceremonial poses, with Hitler standing behind 'cautioning silence' (Radcliff, 1988, p.135). *The Minotaur as a Participant in the Yalta Conference*, 1984-85 (from *Diary* series) shows Stalin's head and raised arm taking up the central four panels, whilst *50 Public Mural Projects for the United Nations Building in New York*, 1987-95 evolved amongst controversy and drama.

Initially, Komar and Melamid produced a series of mural proposals between 1982-88 (often referred as the *Yalta Conference Series*), inspired by a photograph taken at the Yalta Conference, picturing Stalin, Roosevelt and Churchill. However, complications began in 1990, when the artists submitted a mural proposal for a public artwork for the U.N. buildings. The proposal had gained the support of the CITYarts Foundation but was rejected by the Community Board for political reasons. For many former Eastern Europeans living in New York, the thought of Stalin kept bringing back painful memories. They could not accept the fact that an image of Stalin could cover the U.N. buildings. Vitaly Komar explains in his interview with David Glasser that 'in America, censorship moves from the bottom up, unlike the Soviet Union where it came from the top down'. Komar and Melamid escaped governmental censorship imposed by the Soviet Union, only to face another type of censorship in New York, this time imposed by society at large.

The artists' long standing art dealer, Ronald Feldman, once said that 'the day the world is safe is the day that Komar and Melamid are having a show in Moscow' (Brooklyn Museum archives). Their *50 Public Mural Projects* proved that even in New York they could not get the unlimited artistic freedom they sought.

Despite being rejected by the Community Board, Komar and Melamid believed in their project and turned the *Yalta Conference Series* into *50 Public Mural Projects* which they displayed at *Between War and Peace* – an exhibition dedicated to the 50th anniversary of the end of the Second World War and the establishment of the United Nations. A ballot box, which allowed the viewer to vote for his or her favourite version, was an integral part of the installation.

Sources:

- Brooklyn Museum archives
- online archives of Storefront for Art and Architecture
- K&M official website
- Glasser interview with Vitaly Komar
- Carter Radcliff *Komar and Melamid*

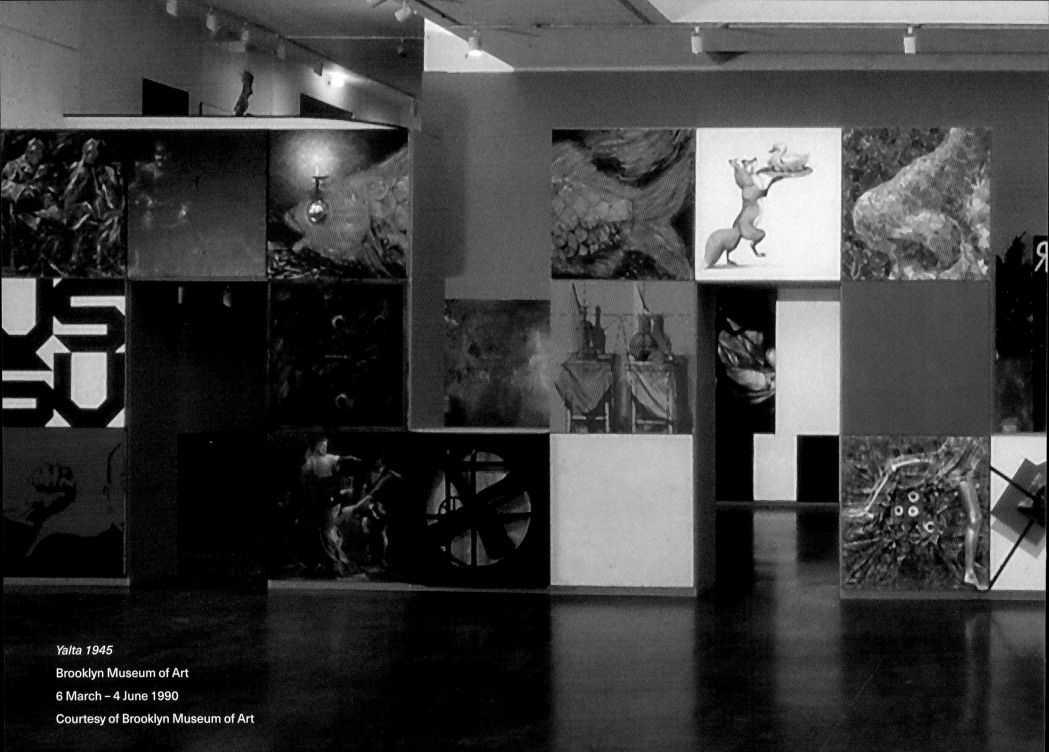

Yalta 1945
Brooklyn Museum of Art
6 March – 4 June 1990
Courtesy of Brooklyn Museum of Art

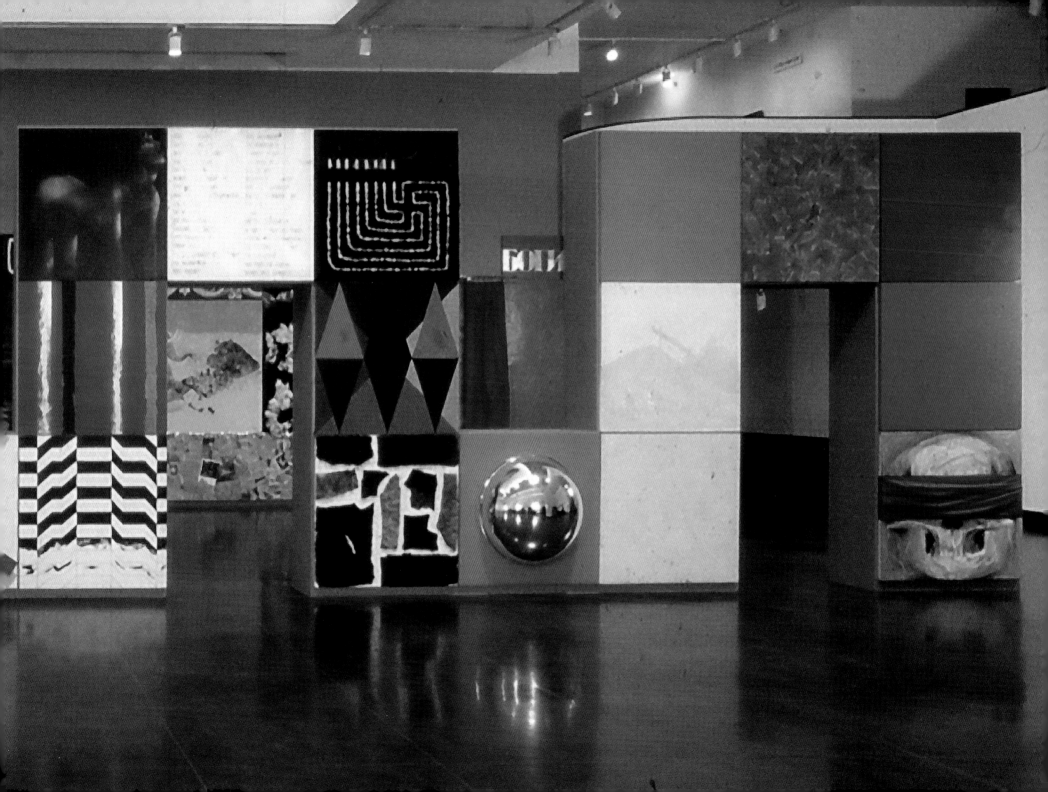

Yalta 1945: An interpretation

<div align="right">Katherine Lucas</div>

Yalta 1945, composed of 31 square panels, each 48 x 48 inches, forms a monumental installation of representational images, which can be configured in multiple ways. The image on the immediately previous double page spread shows the installation in a rectilinear zigzag, as displayed at the Brooklyn Museum of Art in 1990. The representational images are interrupted at regular intervals by blank monochromes. *Yalta 1945* polyptych represents contrasting and conflicting visual ideas, an example of what Vitaly Komar calls 'Conceptual eclecticism', where the 'works created in this movement represent contrasts and eclecticism of our contemporaries' consciousness. As now, in Russia and in the West, people can simultaneously believe in God and in Darwin.'[1] This extends not only to the stylistic treatment of the individual panels, for example, the use of empty areas of monochrome colour versus figuration, abstraction, photo-realism or images of Russian icons, but also the specific content of the images themselves. Equally, the artist has the freedom to construct the installation in many different ways, using various polyptychs, diptychs and triptychs.

The majority of the images contain impressions of 'official' Moscow, where men are the protagonists, apart from one panel that depicts the artists' mothers – who did not know each other – as girls. Set outside of Moscow, the image – based on a pair of snapshots found in the artists' family albums – is in stark contrast to the public nature of the other images, giving the work a domestic touch.

The first panel features a cropped image of Lenin with a closed fist, above which are the letters USSU, for the United States and the Soviet Union. Above the letters are three panels that depict the 'Big Three' at the Yalta Conference: Churchill, Roosevelt and Stalin. The 'Western' leaders are portrayed in an exaggerated Abstract Expressionist style, juxtaposed against the 'Eastern' leader in the dark and heavily varnished Socialist Realist style imposed by Stalin in the Soviet Union. This representational clash in style can represent the physical clash that the Big Three had at Yalta and, as Vitaly Komar mentions, also all clashes and contradictions that appear in the history of art.[2] In *Yalta 1945*,

clashes also appear in the contrast between figuration versus the absence and nothingness in the blank squares.

Germany is symbolized by a large fish, sliced into two panels, which refers to the plans made at Yalta for Germany's division or dismemberment into the four Allied Occupation zones. A history painting of the Judgement of Solomon echoes this theme, where King Solomon prepares to divide an infant between two mothers, but unlike the post-war world, the infant is left whole. Next is a panel containing an industrial fan that, according to Vitaly Komar, symbolises the 'winds of history,'[3] allowing each panel to connect and flow, enabling the images to link into a whole narrative, as in memory and dreams. As the Big Three divided the world, in *Yalta 1945* a still-life composition is divided into compartments in a constructivist manner.

A fox presents its prey, a duck on a silver platter, as a metaphor of dominance, whilst an enormous nose smells the tasty morsel from a nearby panel. Two legs – one skeletal, the other plastic but whole – straddle a tic-tac-toe board which is a reference to political games and their consequences – the game is stalemated. Next to this is Christ depicted as a Russian icon, leading to a black and white zig-zag that then forces our eyes upwards to stripes that then turn into a nude, crouching woman. The elongation of her body objectifies her cry of despair – which is not reflected in the Russian texts to her right – and which, when translated, reads: 'Don't worry', 'Somebody loves you', and 'Everything is all right.' However, the next image demonstrates that everything is 'not right', as a swastika wraps around itself into the eight arms of a *Hanukkiah*, the Jewish ceremonial candelabrum. A metal dome placed on a pink panel appears alone, looking like the 'emblem of a world rendered featureless in the aftermath of Yalta'.[4]

Yalta 1945 ends on a pessimistic note with four blanks followed by an upside-down skull that has been gagged with a red blindfold, showing their 'wit beyond melancholy to blank despair that freezes the play of meaning'[5].

1 Quotation received by e-mail correspondence from Vitaly Komar, 26 August 2016.

2 See Vitaly Komar's interview with David Glasser, this catalogue p. 18.

3 See Vitaly Komar's interview with David Glasser, this catalogue p. 20.

4 See Carter Radcliff, p.171

5 See Carter Radcliff, p.171

Yalta 1945: Exhibition History

Katherine Lucas and Kalina Kossowska

documenta 8, 12 June – 20 September 1987
Brooklyn Museum of Art, New York, 16 March – 4 June 1990
Ben Uri Gallery and Museum, London, 15 September – 18 December 2016

documenta 8

Yalta 1945 was created specifically for, and first exhibited alongside *Winter in Moscow 1977*, at documenta 8 (12 June – 20 September 1987) in Kassel, Germany.

Donald Kuspit, art critic and American academic, commented in the catalogue: They bring together 'the storms of nature and history' in the fragmented stories and association puzzles. Every painting shows predictive how nostalgic they are: an omen as good as a relic. The whole work is very anti-authoritarian by structure, but the net of squares connects and equals all the paintings/panels.

Yalta 1945 – Moscow 1977 is tragic in a challenging way, demonstrating a cleavage, that either can exist or not. This reveals the hyper modernistic conflict of our time.'[1]

documenta is seen as the most important exhibition platform for modern and contemporary art in the world. The first documenta was created in 1955 by Kassel painter and Academy professor, Arnold Bode. Following the ending of the Second World War, his aims were to bring Germany back into cultural dialogue with the rest of the world. He was Artistic Director until documenta 4 in 1968. Since the fifth documenta, held in 1972, the exhibition has been 'reinvented' by a new artistic director every five years. Manfred Schneckenburger was the Artistic Director for documenta 8.

317 artists participated, 520 exhibition pieces and 486,811 visitors visited documenta 8.[2] Komar and Melamid's installation was shown at the Museum Fridericianum, which was, along with the Orangerie in Karlsaue Park, presented paintings, sculptures and installations. The exhibition also continued into six additional venues – parks, streets and public locations surrounding the Museum: Karlsaue Park, Kasseler Innenstadt; Kulturfabrik Salzmann; Renthof; Diskothek "New York"; Karlskirche.

Brooklyn Museum of Art

Yalta 1945 was exhibited for the second time at the Brooklyn Museum of Art in New York, from 16 March – 4 June 1990,[3] alongside *Winter in Moscow 1977*, as part of the Grand Lobby Project, a series that began in 1984.[4]

Bob Buck, the Director of the Brooklyn Museum of Art, and curator, Charlotta Kotik, invited Komar and Melamid to reinstall the panels; whilst the display was curated by Assistant Curator Brook Kamin Rapaport. When looking back to the 1990s, Rapaport commented that 'installation work was not as prevalent in the art world as it is today. This was an opportunity for contemporary artists to display vanguard, often monumental work in a capacious interior setting. They were able to push content and scale. Artists in the Grand Lobby series included Houston Conwill, Petah Coyne, Alfredo Jaar, Joseph Kosuth, Sol LeWitt, Donald Lipski, and Meg Webster'.[5]

Ben Uri

Yalta 1945 is displayed alone for the first time at Ben Uri Gallery & Museum in London, from 16 September – 18 December 2016. The gallery spaces divide the work into four, providing yet another interpretation of the 'game'. Each time it is displayed, the panels will not necessarily follow the exact same order, although various triptychs and diptychs will always remain together. The 'game' will always start and end with the same panels, but what happens in between is up to interpretation by the artist. As Vitaly Komar clearly states in his interview: 'the order could conceivably be changed'.[6]

1 Documenta catalogue, p.132 (original in German)
2 See http://www.documentaarchiv.de/en/documenta/documenta-8.html
3 See Komar and Melamid: *Yalta 1945 & Winter in Moscow 1977*, https://www.brooklynmuseum.org/opencollection/exhibitions/1154.
4 Information received from Brooke Kamin Rappaport, the Assistant Curator of the Grand Lobby series.
5 Quotation from an e-mail from Brooke Kamin Rappaport.
6 See Vitaly Komar's interview with David Glasser.

IN CONVERSATION

Интервью Дэвида Глассера у Виталия Комара: Ялтинская конференция

В этом году работа Виталия Комара и Александра Меламида «Ялта 1945», показанная в 1987 на «documenta 8» и в 1990 в Бруклинском музее, будет показана в Лондонском Музее Ben Uri.

С 2003 года художники работают индивидуально, но образы Ялтинской конференции продолжают появляться в работах Виталия Комара.

Директор музея Дэвид Глассер встретился с художником.

Дэвид Глассер (Д.Г.):
Виталий, расскажи, как тема Ялты появилась в творчестве Комара и Меламида?

Виталий Комар (В.К.):
О! Это долгая история. Я родился в Москве в конце второй мировой войны. Когда мне было немногим более года, в Крыму происходила знаменитая Ялтинская конференция, где Сталин встречался с Черчиллем и Рузвельтом. Союзники подготовились к победе 1945-го года, договорились о будущем устройстве мира и основании ООН. Через много лет после этого я эмигрировал в Нью Йорк и там впервые увидел фотографию этой встречи.

Неожиданно образы этой фотографии околдовали меня. Необъяснимая сила погрузила меня в калейдоскоп разных и противоречивых впечатлений моей жизни. Жизни в разных мирах. В мире Сталина и в мире Рузвельта и Черчилля.

Vitaly Komar in conversation with David Glasser: The Yalta Conference

This year Komar and Melamid's *Yalta 1945*, first shown at *documenta 8* at Kassel in 1987 and later at the Brooklyn Museum in New York in 1992, will be on view at the Ben Uri Gallery in London.

Since 2003 the artists have worked individually, but images of the Yalta Conference continue to appear in the works of Vitaly Komar.

Ben Uri Chairman, David Glasser, met with the artist.

David Glasser (D.G.):
Vitaly, tell me how the Yalta theme first appeared in the work of Komar and Melamid?

Vitaly Komar (V.K.):
Oh, that's a long story. I was born in Moscow toward the end of World War II. When I was just over a year old, the Yalta Conference, that famous meeting of Stalin, Churchill and Roosevelt, took place in the Crimea. The Allies were preparing for victory in 1945 and were negotiating the future world order and the founding of the United Nations. Many years later, after I immigrated to New York, I saw a photograph of that meeting for the first time.

Quite unexpectedly, the photograph enchanted me. It felt as though some inexplicable power plunged me into a kaleidoscope of contradictory images and impressions from my past and present, my life in different worlds: in the world of Stalin, the world of Roosevelt, and the world of Churchill.

Этот эклектичный и абсурдный калейдоскоп появлялся во многих моих работах, сделанных как индивидуально, так и совместно с Аликом Меламидом. Самой известной из работ на тему Ялты стал полиптих «Ялта 1945», показанный на documeta 8 в конце 80х.

Д.Г: В этом году эта работа будет показана у нас, в Лондонском Музее Бен Ури. Как бы ты описал её образы и концепции?

В.К: Полиптих «Yalta 1945» состоит из 31-й картины. Каждая из них – это квадрат 48» x 48». Все картины выполнены в разных техниках: темпера, масло, смешанная техника и ассамбляж. Некоторые из них на холсте, некоторые на дереве. Разные стили картин отражают не только смену настроений, но и разные периоды истории искусства и концептуальную эклектику современного сознания. В наших головах мирно сосуществуют контрастирующие образы и противоположные концепции. На мой взгляд, эклектика равнозначна плюрализму и толерантности. Все мы объединяем в себе дивергентные образы и противоположные концепции, которые сосуществуют в нашем сознании. Мы верим и в Дарвина, и в Бога.

В моей голове, например, как в миске с русским салатом, смешаны продукты самого разного вкуса. Я люблю работы совершенно разных и порой противоречивых мастеров, художников разных стилей, направлений в искусстве, разных времён и народов.

Я вижу всеобщую историю искусства, как эклектичный полиптих, полный контрастов и противоречий. В этом ряду триптих, таящийся в Ялтинской фотографии, не менее противоречив и эклектичен, чем общая история искусств. Мы видим сидящих вместе трёх союзников: Слугу Королевы, Демократа Президента и Кровавого Диктатора. Для меня, образы этой фотографии стали в итоге визуальным символом того, что я называю «концептуальной эклектикой».

This eclectic, and sometimes absurd, kaleidoscope has appeared on and off in my work, both individual, and together with Alex Melamid. The best known work on Yalta theme was the multi-panelled *Yalta 1945*, shown at *documenta 8* in the late '80s.

D.G: This year *Yalta 1945* will be shown at the Ben Uri Gallery. How would you describe the concept of the installation, and the images in it?

V.K: *Yalta 1945* is a polyptych consisting of 31 paintings. Each panel is a 48-x-48-inch square, but the mediums vary: you have oil, tempera, mixed media and assemblage. Some are on canvas, but a number are on wood. The different styles of the paintings reflect changes in mood, as well as different periods of art history, which in turn reflects the larger conceptual eclecticism of contemporary consciousness. For me, eclecticism is synonymous with pluralism and tolerance. All of us have divergent images and conceptual opposite coexisting in our minds. We believe in Darwin, and in God.

My mind is like a 'Russian salad' filled with wide array of tastes and textures. I love the art of very different and what you might think are incompatible artists, styles, movements, times and peoples.

I view the history of art as a whole as an eclectic polyptych, full of contrasts and contradictions. The triptych at the heart of the Yalta photographs is just as contradictory and eclectic as art history, if you think about it. We have the three allies sitting next to one another: the King's Servant, the Democratic President, and the Bloody Dictator. For me, the image in this photograph has become a visual symbol of what I call 'conceptual eclecticism'.

The polyptych begins with the images of Churchill and Roosevelt drawn from the Yalta photograph, but executed in a painterly, expressionistic style; in the second panel Stalin is painted in a traditionally realistic style, and the panel fades into darkness to the right of him.

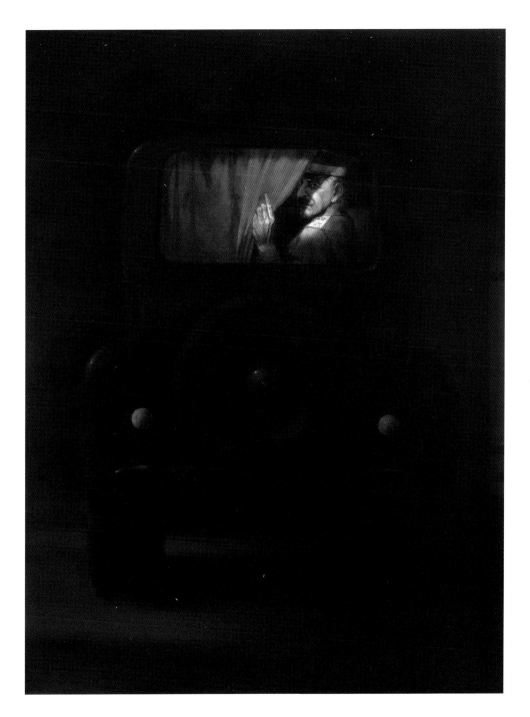

Komar and Melamid

I Saw Stalin Once When I Was a Child, 1981-82

Oil on canvas

72 x 54 inches

Courtesy of Ronald Feldman Fine Arts, New York

Полиптих начинается с образов Черчилля и Рузвельта, взятых из фотографии Ялтинской конференции, но выполненных художественно в экспрессионистической манере; следующая панель с изображением Сталина выполнена в традиционной манере соцреализма, и большую часть панели занимает темнота, обволакивающая его фигуру.

Следующая панель – это концептуальный поп-образ, созданный из аббревиатур, формирующих зеркальное отражение акронимов супердержав: US/SU. Затем следует классический «Суд Соломона» – традиционный сюжета искусства Возрождения. Фигура воина, держащего ребенка, и меч, вознесенный над ними, символизируют послевоенный раздел Европы, который произошел в результате Ялтинской конференции. Одна из панелей, находящихся в нижней части инсталляции, совмещена с большим индустриальным вентилятором, олицетворяющим «ветра истории».

Последовательность квадратов и образов «Ялты 1945», как детские кубики, может постоянно меняться. Образы меняются, но панели следуют определенной идее, напоминая путь по лабиринту. Иллюстрация к детской сказке, в которой лиса несет на подносе жареную утку, соседствует с изображением огромного носа. Следующая композиция соединяет изображение средневековой православной иконы с авангардными элементами. Затем следует эротическое изображение обнаженной, которое перерастает в абстрактную экспрессионистическую панель и затем – в геометрическую композицию в стиле Оп-арта. Панели сменяют друг друга иногда в абсурдном калейдоскопе, напоминающем игру в классики: голова и хвост рыбы на разных панелях, менора, композиция с кусочками меха, трехмерное сферическое зеркало. И все это перемешано с монохромными панелями желтого, зеленого, голубого и красного цвета.

Next is a conceptual, pop-art rendering of the superpowers' names abbreviated as a mirror image: US/SU. Then comes a classical 'Judgment of Solomon', which was a frequent subject in Renaissance painting. The figure of a soldier holding an infant and a sword symbolizes the post-war division of Europe that emerged from the Yalta Conference. There is a large industrial fan, symbolizing the 'winds of history' in one of the lower panels.

The squares in *Yalta 1945* remind me of blocks or puzzle pieces in a children's game, where the order could conceivably be changed. The images change, but the panels follow a pattern reminiscent of a path through a labyrinth. In one square an illustration of a Russian children's story shows a fox holding a roasted duck on a tray, as if carrying it toward the next painting, which depicts a huge nose. A subsequent composition incorporates images of medieval Russian icons into Russian avant-garde motifs. This is followed by an erotic female nude that metamorphoses into an abstract expressionist panel, and then op-art-like geometric ornamentation. Images follow in quick, sometimes absurd succession like a kaleidoscope version of hopscotch: there's a pink fish, its head and tail on different squares; a menorah; a panel of fur; a three-dimensional spherical mirror—and all are interspersed with a variety of yellow, green, blue, and red monochromes.

The piece ends with the hybrid image of a blindfolded skull—an attribute of Justice overlaid on the emblem of Vanitas.

D.G: Why is the work called *Yalta 1945*? The conference was held in secret, but it is well known that the strategy was negotiated through the second half of 1944.

V.K: Because 1945 was when the plans made at the conference came to fruition. The Allies won and even though Roosevelt didn't live to see the end of the war, the idea of a new world order and the creation of the United Nations was victorious.

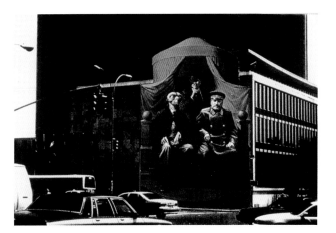
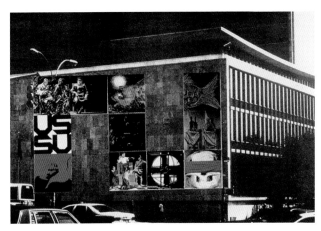
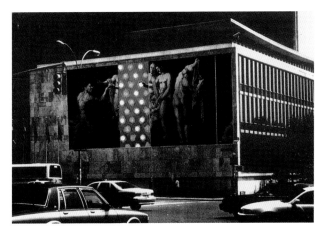
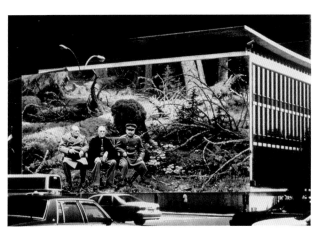

Komar and Melamid

*50 Public Mural Projects
for the United Nations
Building in New York*

Courtesy of the Former Archive
of Komar and Melamid

Кончается полиптих изображением черепа с повязкой на глазницах – гибридом эмблемы Vanitas и атрибута Фемиды, слепой вершительницы судеб.

Д.Г: Почему работа называется «Ялта 1945»? Конференция была проведена в полнейшем секрете, но известно, что важнейшие решения были приняты в течение переговоров во второй половине 1944.

В.К: Это связано с тем, что в 1945 большинство планов союзников были осуществлены и итоги конференции стали реальностью. Союзники победили и, хотя Рузвельт не дожил до этого, идея нового мира была превращена в жизнь при создании ООН.

Д.Г: Почему фотография Ялты так околдовала тебя и вызвала появление столь противоречивых образов? Можешь ли ты сейчас вспомнить и описать возможные причины и происхождение этого?

В.К: Хорошо, постараюсь, как археолог докопаться до самых ранних слоёв моего сознания.

С раннего детства образы Сталина, окружали меня везде, даже в спальне. Когда мне было 5 лет, мои родители развелись и мама заменила висевшую над моей кроватью фотографию отца портретом Сталина. Как и мой отец, Сталин был в военной форме. Кроме того, одним из самых известных титулов вождя был титул «Отца Народов».

В семь лет, я поступил в школу. В первый же день вместе со всем классом я должен был громко декламировать: «Спасибо товарищу Сталину за наше счастливое детство!». Этот же лозунг был написан над входом в школу. Красный фон и белые буквы с белым восклицательным знаком, Когда мне было 10, отец народов умер.

D.G: Why did the photographs from Yalta captivate your imagination and evoke so many contrasting images? Can you recall their origins, or explain the reason for this fascination?

V.K: Very well. I'll try to play archaeologist and dig down to the earliest layers of my consciousness.

From childhood I was surrounded by images of Stalin, even in my bedroom. When I was five years old, my parents divorced, and Mama exchanged the photograph of my father hanging next to my bed with one of Stalin. Like my father, Stalin was dressed in a military uniform. Moreover, one of the most common honorifics for Stalin was 'Father of All the Peoples'.

I started school at age seven. On the first day, the entire class had to proclaim loudly: 'Comrade Stalin, Thank You for Our Happy Childhood!'. The same slogan hung over the entrance to our school. The background was red and the letters and exclamation mark were white. In 1953, when I was ten, the Father of all the Peoples died. The people were orphaned. The new leader, Nikita Khrushchev, ordered statues of Stalin to be destroyed and banished his image.

After Stalin died, Mama substituted a picture of the Mona Lisa for the portrait of Stalin in my bedroom. The previous year, everyone had celebrated the 500th anniversary of Leonardo da Vinci's birth. Almost as many pictures of Mona Lisa, with her famous smile, were printed for the occasion as portraits of Stalin and his famous moustache. Gradually, the succession of portraits that hung over my childhood bed merged in my muddled head. Today, when I see Marcel Duchamp's moustachioed Mona Lisa, I am reminded of my happy childhood.

For over 20 years before Stalin's death, his image surrounded every Soviet person, not just me. Portraits of Stalin were everywhere: in books for children and adults, in magazines and newspapers, in the movies and at exhibitions, on each floor of my school, on the walls and roofs of buildings,

Народы осиротели. Новый вождь Никита Хрущёв приказал разрушить памятники Сталину и запретил его изображения.

После этого мама заменила портрет Сталина портретом Моны Лизы. За год до смерти Сталина, все праздновали 500-летие Леонардо да Винчи. В связи с этим, портретов Моны Лизы с её знаменитой улыбкой было напечатано не меньше, чем портретов Сталина с его знаменитыми усами. Все портреты, висевшие над моей детской кроватью, смешивались в моей бедной голове. Сегодня, когда я вижу усатую Мону Лизу Марселя Дюшана, я вспоминаю своё счастливое детство.

До смерти Сталина его изображения окружали не только меня, но и всех советских людей. Они были в книгах для детей и взрослых, в журналах и газетах, в фильмах и на выставках на каждом этаже моей школы, на стенах и крышах зданий и на даже в небе. Как сейчас я понимаю, образы визуальной пропаганды были, так сказать, «имплантированы» в мой детский мозг.

Но однажды, когда мне было шесть лет, я увидел не нарисованного, а живого Сталина. И не в моей спальне, а на улице Алексея Толстого. Вместе с моим дедом мы шли по этой улице, Неожиданно нас остановила охрана. Из ворот готического особняка Молотова на большой скорости выезжала вереница одинаковых чёрных автомобилей. На мгновение за окном одного из них я увидел всем знакомое лицо. Наши глаза встретились. Затем лицо Сталина исчезло.

Мой дед был старым евреем, глубоко напуганным советской властью. Сегодня я понимаю, почему он просил меня никому не говорить об этом и сказал мне, что это был не Сталин, а просто какой-то усатый военный.

Много позже, когда я уже стал профессиональным художником, воспоминание об этом «мираже» превратилось в картину «Я видел Сталина однажды, когда я был ребенком «(1981-82). Она стала частью серии «Ностальгичсекий Соц-Реализм», сделанной вместе

and even in the sky. I later realized that this visual propaganda had been firmly 'imprinted' on my young brain.

One time, when I was six years old, I actually saw the real, living Stalin. Not in my bedroom, but on Aleksei Tolstoy Street. My grandfather and I were walking somewhere. Suddenly we were stopped by guards. A line of identical black cars drove out of the gates of Vyacheslav Molotov's gothic mansion at high speed. As they passed me, I caught a glimpse of that well known face. Our eyes met. Then Stalin disappeared.

My grandfather was an old man, a Jew who had been deeply frightened by the Soviet authorities. Today I understand why he asked me not to tell anyone about the incident, and tried to convince me that it wasn't Stalin, just some soldier with a moustache.

Many years later, when I had become a professional artist, memories of that 'mirage' were transformed into the painting *I Saw Stalin Once When I Was a Child*, 1981-82. It became part of a series of paintings that Alex Melamid and I called 'Nostalgic Socialist Realism'. Today that piece is in the collection of MoMA in New York.

During my childhood Stalin was often portrayed together with Lenin or other heroes of Soviet history, sometimes even with people whom he had never actually met, such as Karl Marx and Friedrich Engels. But I had never seen the photo of Stalin with Winston Churchill and Franklin Roosevelt – his allies in the historical victory over Hitler. As a young man I visited the Crimea, and Yalta, which is a wonderful city on the Black Sea. I have marvellous memories of the place. But even in the palace/museum, where the Allied leaders met, there were no photograph of them.

D.G: How do you explain this strange absence?

V.K: It was probably one of many decisions taken by Soviet censorship during the Cold War. In those years, Soviet people were shown Churchill and American presidents through the frightening, surrealist lens of

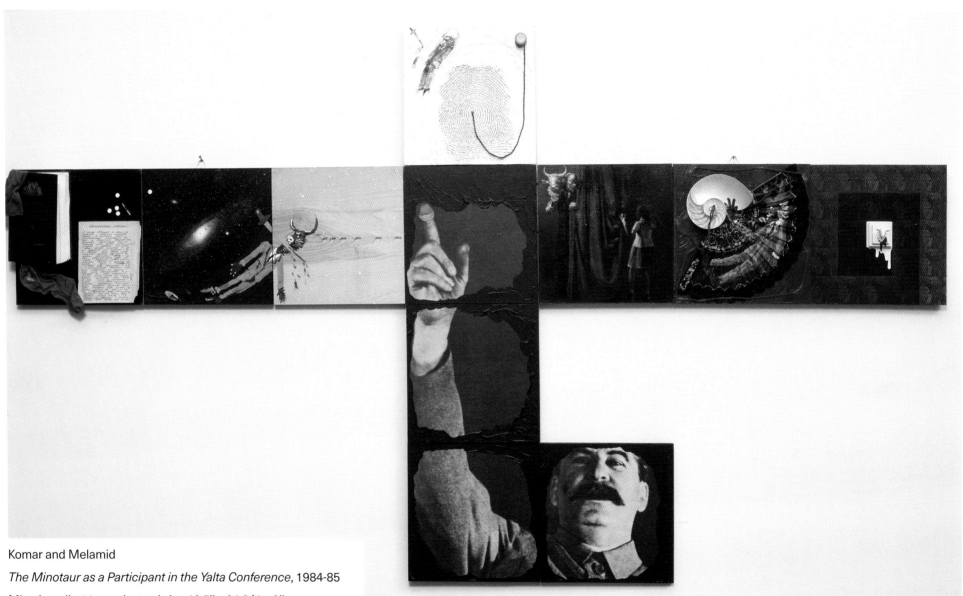

Komar and Melamid

The Minotaur as a Participant in the Yalta Conference, 1984-85

Mixed media 11 panels, total size 40.5'' x 94 3/4 x 3''

Photo: D. James Dee

Courtesy of Ronald Feldman Fine Arts

New York

с А. Меламидом. Сейчас эта работа в коллекции Музея современного искусства (MoMA, New York).

Во времена моего детства, Сталина нередко изображали вместе с Лениным или другими героями истории. Иногда даже с теми, с кем он никогда не встречался: например, с Карлом Марксом и Фридрихом Энгельсом. Но я никогда не видел изображений Сталина с Уинстоном Черчиллем и Теодором Рузвельтом – его союзниками в исторической победе над Гитлером.

Позднее, в юности я бывал в Крыму и Ялте. Прекрасный город у чёрного моря! У меня осталось незабываемое чудесное впечатление. Но даже во дворце/музее, где встречались лидеры союзников, их фотографий не было.

Д.Г: Как ты мог бы объяснить это странное отсутствие ?

В.К: Вероятно, это являлось результатом одного из тайных решений, принятых советской цензурой во времена холодной войны. В те годы советские люди могли видеть Черчилля и американских президентов только в страшном сюрреалистическом мире политической сатиры. В мрачных и несмешных чёрно-белых рисунках западные лидеры изображались в виде злых свинообразных и козлообразных чертей. Прошло немало лет, прежде чем я стал понимать, что миражи моего детского мира были опасной иллюзией.

Повторю ещё раз, впервые я увидел фотографию Ялтинской конференции в 1978 году в Нью Йорке. Эта фотография, неожиданно, погрузила меня в калейдоскоп образов, прямо и косвенно связанных со многими впечатлениями моей жизни. Я увидел трёх союзников, как три разных эмблемы, три разных олицетворения противоречивых концепций, стоящих за каждым из них.

Этот метафорический «триптих» поразил меня своей «концептуальной эклектикой». Мне кажется, самым ранним

political satire. Gloomy, humourless black-and-white drawings portrayed the Western leaders as evil swine and goat-like devils. It was quite some time before I realized that the mirages of my childhood world were dangerous illusions.

As I said earlier, the first time I saw the photograph of Yalta was in 1978, in New York. The photograph suddenly plunged me into a kaleidoscope of images that were directly and tangentially connected to different aspects of my life. I saw the three allies as emblems, three personifications of the three different and incompatible concepts that stood behind them.

I was struck by the conceptual eclecticism of this 'metaphorical triptych'. Some of the earliest appearances of this type of symbolic eclecticism were the hybrids in ancient mythologies that combined images of man and beast. In our historical time, photographs of the Yalta meeting combined juxtaposed political mythologies. I saw the image of these three men as a single creature--a three-headed, multi-armed ruler, who combined the contradictions of monarchy, tyranny and democracy.

What brought such different people together as allies? The answer is simple: a common enemy. And in fact, one of the first paintings on the Yalta theme was *The Yalta Conference (From a History Textbook, 1984)*, 1982 where Hitler appears as a participant in the Yalta Conference, standing like a shadow figure behind Roosevelt (as ET) and Stalin. Like *I Saw Stalin Once When I Was a Child*, this work was part of the 'Nostalgic Socialist Realism' that Melamid and I produced together.

D.G: Images of Yalta have appeared at different times in many of Komar and Melamid's works, including the series '50 Public Mural Projects for the United Nations Building in New York', 1987-95, which I find particularly interesting. Tell us a bit about that project.

V.K: That series originated in a big drama. In 1990, we submitted three mural proposals for a public art work at the U.N. One of them was chosen

появлением подобной эклектики были гибриды древних мифов, соединивших образы человека и зверя. В новой истории, образы политической мифологии соединились в фотографии Ялтинской встречи. В ней я увидел трёхглавого и многорукого правителя, совместившего в себе старые и новые противоречия монархии, демократии и тирании.

Что сделало столь разных людей союзниками? Ответ прост: общий враг. Поэтому в одной из первых картин на эту тему «Ялтинская конференция: учебник по истории из будущего» (1981–82), появилась фигура Гитлера. Как и «Я видел Сталина однажды, когда я был ребенком», эта работа вошла в серию «Настальгичекий Соц Реализм» сделанную совместно с Аликом Меламидом.

Д.Г: До твоего проекта «Трехдневный выходной», образы Ялты появлялись во многих сериях и проектах Комара и Меламида. Например, несколько полиптихов, 1984–5, в их числе «Миноавтр, участвующий в Ялтинской конференции».

Особенно интересна серия «50 эскизов для монументальный росписи здания ООР в Нью-Йорке» (1987 – 95). Расскажи об этих проектах.

В.К: Эти проекты связаны с весьма драматической историей. В 1990-м году один из проектов этой серии был утверждён организацией CITYart Foundation, но, к сожалению, местные жители не дали свое согласие . Я встречался с одним из членов комиссии, и он сказал, что в районе здания ООН живёт не мало выходцев из восточной Европы. Для них Сталин – это зло. Я ответил, что даже в католических храмах разрешались изображения Сатаны. Но мои доводы ничего не изменили. Тогда я понял, что, в отличие от Советского Союза, в США цензура идет снизу вверх, а не сверху вниз.

and approved by the CITYart Foundation, which was overseeing the project. The Yalta image was part of that mural proposal. Unfortunately, it was rejected by the neighbourhood Community Board, which also had to approve the final choice. At the time, I met with one of the members of the Community Board and he told me that many former Eastern Europeans lived in the U.N. area. For them, he said, Stalin was the incarnation of evil, and they wouldn't want to see him portrayed at the U.N. I pointed out that even in Catholic churches depictions of Satan were allowed. But my argument had no effect. That was when I realized that in America, censorship moves from the bottom up, unlike the Soviet Union where it came from the top down.

Even though the mural project wasn't accepted, the subject was intriguing, and those first mural proposals grew into the series '50 Public Mural Projects', which we exhibited at the Storefront for Art & Architecture in 1995 in honour of the 50th-anniversary of the end of World War II and the establishment of the United Nations.

D.G: In 2003, you and Alex began working individually, yet Yalta continued to appear in your work, for instance, the 'Three-Day Weekend' project. Why was that?

V.K: Whenever I looked at the actual photographs of the Yalta 'troika', my imagination 'secreted' three strands of unexpected images. This 'secretion' is similar to the conditioned reflex of salivation in Pavlov's dogs. But these visions often seemed absurd to me, and I couldn't explain their connection to the Yalta Conference. For example, in one painting based on that photograph, Roosevelt's body appeared with the head of the alien ET, from Steven Spielberg's popular film; or in a number of polyptychs from the "Diary" series (1984–85), including *The Minotaur as Participant in the Yalta Conference.*

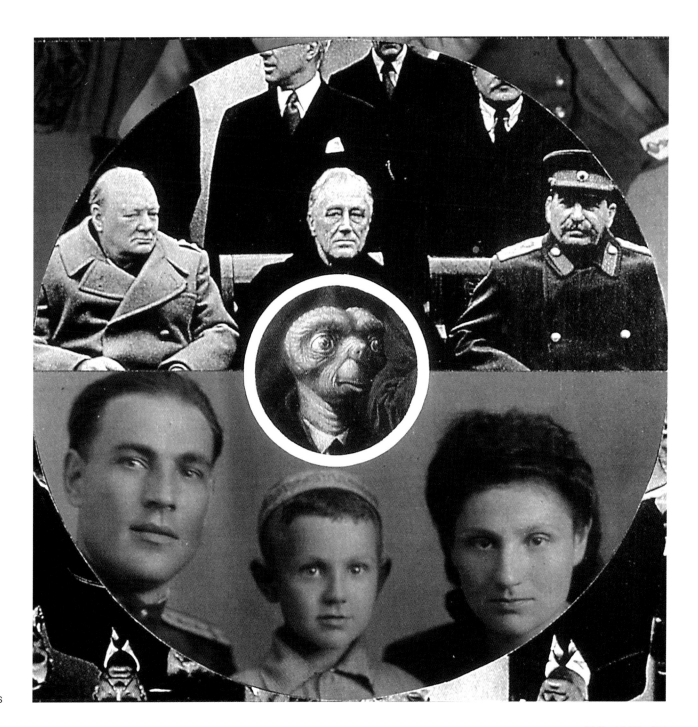

Vitaly Komar

Fragile Unity with E.T. (from Three-Day Weekend), 2004-2005

DETAIL

Mixed media on paper

40 x 30 inches

Photo: Alan Zindman

Courtesy of Ronald Feldman Fine Arts

В 1995 году, к юбилею конца второй мировой войны и создания ООН серия проектов для ООН была закончена и выставлена в Storefront for Art & Architecture. В некоторых из них повторялись образы панелей из полиптиха «Ялта 1945», с описания которого мы начали это интервью.

Д.Г: С 2003 года и ты и Алекс работаете индивидуально, Но Ялта продолжает повторятся в твоём проекте «Три выходных». Почему?

В.К: Потому что всегда, когда я вглядываюсь в документальную фотографию этой политической «троицы», моё воображение «выделяет» вереницы неожиданных для меня образов. Их «выделение» подобно условному рефлексу выделения слюны у собак Павлова. Но связь этих видений с Ялтинской конференцией часто казалась мне необъяснимой и абсурдной. Например, в одной из картин, появилась фигура Рузвельта с лицом инопланетянина-ребёнка, ET из популярного фильма Спиллберга или во многих полиптихах из серии «Дневник» (1984-85), включая «Минотавр как участник Ялтинской конференции».

В 2003 году я нашёл объяснение связи Рузвельта с образом ET. Я нашёл забытую и когда-то мною любимую детскую фотографию. На ней я сижу вместе с отцом и матерью в центре нашей «семейной троицы». На Ялтинской фотографии Рузвельт, как и я на моей детской фотографии, тоже находится в центре. А место мамы занимал Сталин. Вероятно, в Америке я подсознательно чувствовал себя, своего рода, ET – инфантильным пришельцем из иного мира. Пришельцем из иной планетной и, возможно, из иной политической системы.

Когда я начал видеть эту связь, началась работа над проектом («Три выходных»). В 2006 году часть этого проекта была показана в музее Ben Uri. В этом проекте соединились образы Ялтинской конференции с образами моей детской семейной фотографией

Many years later, I began to understand the connection between Roosevelt and the image of ET. I found a long-forgotten photograph from my childhood, where I am sitting between my parents, in the centre of our 'familial troika'. I am in the middle, like Roosevelt in the Yalta photograph. My mother is in the place occupied by Stalin. I think it's possible that living in America I subconsciously felt that I myself was a sort of ET – an infantile creature from another world, an alien from another planet and another political system.

Once I understood this connection, I began work on the 'Three-Day Weekend' project. [In 2006, part of this project was exhibited at the Ben Uri Gallery, D.G.] In that project, images of the Yalta conference combined with my childhood family photograph and emblems of different religions. I saw the eclecticism of utopian ecumenism as being connected to my personal biography.

My mother was raised in a family with Jewish traditions, and my father in a family with Christian traditions. But in the Soviet Union, the country of 'atheist fundamentalism', my parents became members of the Communist Party. Thus the culmination of this project were works in which religious pop symbols were united with political pop emblems like the Soviet hammer and sickle, a symbol of social utopia.

A similar combination can be seen in Austria's state emblem – a two-headed eagle holding a hammer and sickle in its talons. It would actually be a good symbol for Putin's Russia. It's an old tradition: in the Metropolitan Museum I saw a similar combination in an ancient Byzantine relief carved in ivory: Adam holds a hammer, and Eve a sickle.

Interview June 2016 translated from the Russian by Jamey Gambrell

и с эмблемами разных религий. Я увидел абсурдную эклектику утопического экуменизма в связи со своей биографией.

Моя мама выросла в семье с традициями иудаизма, а отец – в семье с традициями христианства. Но в Советском Союзе, в стране «атеистического атеизма, мои родители стали членами коммунистической партии. Потому завершением проекта стали работы, где религиозные поп-эмблемы соединились с поп-эмблемами политическими. Например, с поп-символом социальных утопий – с серпом и молотом.

Подобное соединение можно видеть на государственном гербе Австрии – двуглавый орёл, в когтях которого серп и молот. Такой византийский орёл с советскими эмблемами мог бы стать хорошим символом Путинской России. Другое схожее соединение я видел в средневековом византийском рельефе из слоновой кости: Адам с молотом и Ева с серпом.

Виталий Комар
2016

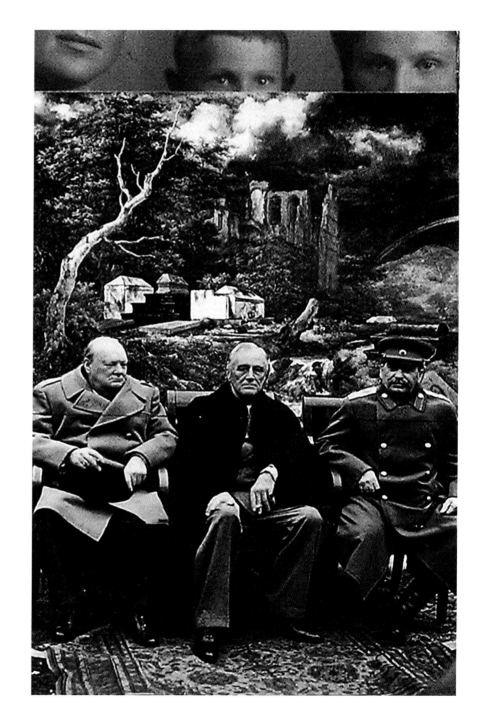

Errata: following pages

Page 32. Caption should read: Izmailovsky Park, Moscow – artists setting up, 1974; Lydia Masterkova, centre. Photograph: Igor Palmin

Page 34. Caption should read: Official Soviet visual propaganda 'official conceptual art' of the 1970s

Page 40. Caption should read: Izmailovsky Park, Moscow: Photographs from a private archive of Mikhail Abrosimov, first published in *Iskusstvo* magazine in 2013. Courtesy of the Calvert Journal, www.calvertjournal.com

Page 45. Caption should read: Izmailovsky Park, Moscow: Artists and public. Photograph by Igor Palmin

Vitaly Komar

Yalta Conference at a Jewish Cemetery, 2004-2005

Mixed media on paper

40 x 30 inches

Courtesy of Ronald Feldman Fine Arts, New York

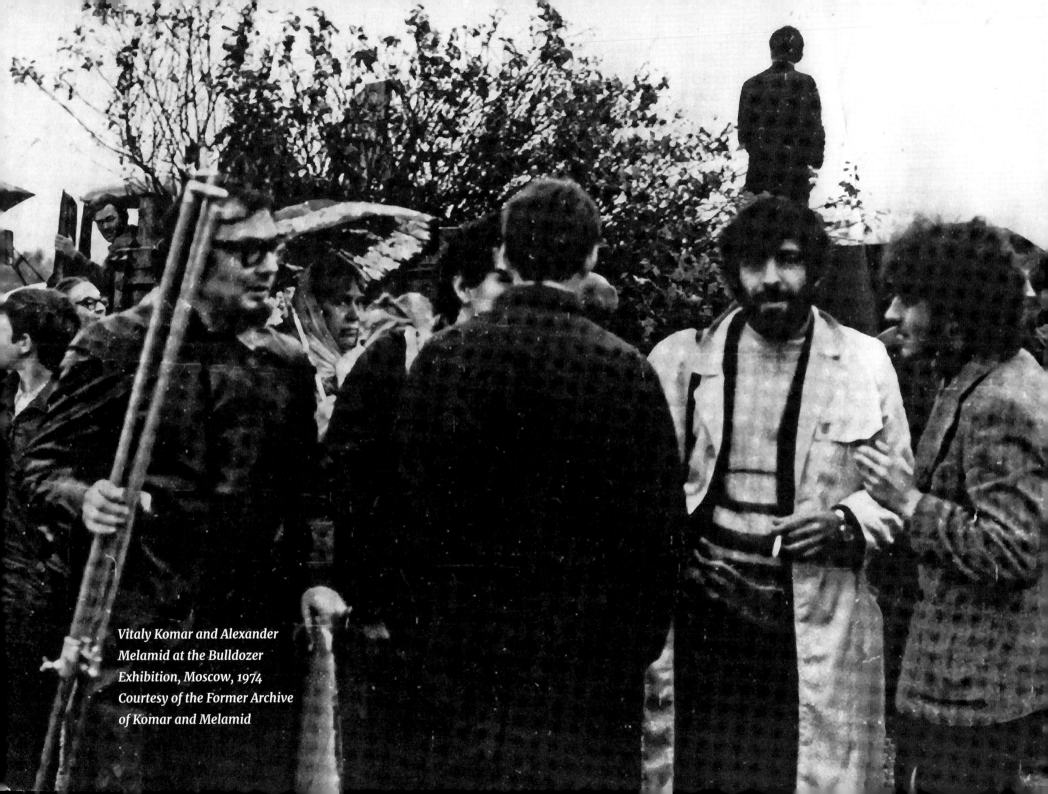

*Vitaly Komar and Alexander
Melamid at the Bulldozer
Exhibition, Moscow, 1974
Courtesy of the Former Archive
of Komar and Melamid*

ВИТАЛИЙ КОМАР

АВАНГАРД, СОЦ-АРТ и БУЛЬДОЗЕРНАЯ ВЫСТАВКА 1974 года

1. Авангард и корни неофициального искусства

Революционная борьба русского авангарда с традициями старой культуры привела к разделению искусства на официальное и неофициальное. До первой мировой войны первый авангард противостоял модному тогда салонному академизму. После второй мировой войны и смерти Сталина второй авангард противостоял официальному социалистическому реализму. Но к тому времени неофициальные художники Советской России утратили наивный нигилизм пионеров авангарда. Вспомнили древнеримский афоризм «ново то, что хорошо забыто», поверили в ценности плюрализма, в постепенную эволюцию моды и приобрели некоторые черты, сближающие их искусство с поздним модернизмом.

Советская власть, как общий враг, объединила эклектичную толпу опозиционеров: от либералов и троцкистов до религиозных националистов и уголовников. Для неофициальных художников эта концептуальная эклектика была альтернативой трагическому экстремизму первых лет революции, когда русский авангард стал «официальным» искусством, вернее стал играть роль «карнавального короля», которого принесли в жертву на заре сталинской культуры. Интересно, что Ленин, в отличие от Муссолини, футуристов не любил, но он использовал их анархическую энергию для разрушения некоторых буржуазных традиций, которые мешали его стремлению к власти. В первые годы революции

VITALY KOMAR

The Avant-Garde, Sots-Art and the Bulldozer Exhibition of 1974

1. The Avant-Garde and the Roots of Unofficial Art

The Russian avant-garde's revolutionary struggle with the traditions of the old culture led to the division of art into 'official' and 'unofficial.' Prior to the First World War, the first avant-garde opposed the academic salon art that was fashionable at the time. After the Second World War and the death of Stalin, the second avant-garde opposed official Socialist Realism. However, by that time Soviet Russia's unofficial artists had shed the naïve nihilism of the early 20th century avant-garde. They were aware of the ancient Roman aphorism: 'The new is simply what has been well forgotten.' They believed in the value of pluralism, in the gradual evolution of fashion, and certain traits of their art were reminiscent of late modernism.

An eclectic crowd was unified under the banner of opposition to the Soviet regime: it ranged from liberals and Trotskyites to religious nationalists and criminals. For unofficial artists, this conceptual eclecticism was an alternative to the tragic extremism of the revolutionary years, when the Russian avant-garde became the 'official' art of the regime. Rather, it played the role of the 'King of the Carnival', who was then sacrificed at the dawn of Stalinist culture. It is curious that Lenin, unlike Mussolini, did not like the Futurists; however he used their anarchic energy to destroy a number of bourgeois traditions that hindered his pursuit of power. In the first years of the revolution, avant-gardists established a bureaucratic state system of support for art, and they enjoyed the privileges of the

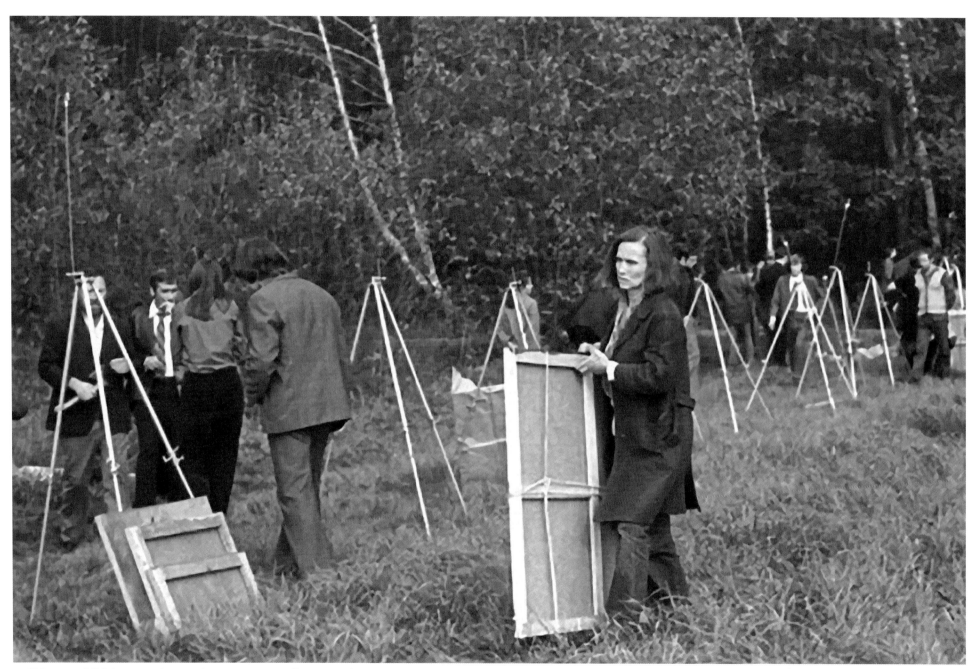

Bulldozer exhibition – artists setting up, 1974; Lydia Masterkova, centre. Photograph: Igor Palmin

авангардисты создали государственно бюрократическую систему поддержки искусства и пользовались привилегиями советской элиты. Большинство же старомодных художников на короткое время революционного карнавала стали неофициальными нонконформистами и голодали в подполье. Правда, позднее они взяли реванш, свершили «дворцовый переворот», пришли к власти и посадили на хлеб и воду авангардистов. Сегодня мы часто забываем, что и официальный авангард, и официальный реализм были двумя сторонами одной медали – одной социалистической утопии.

Пародоксальный урок «советского эксперимента» заключатеся в том, что на исторической сцене в период господства авангардного элитизма в роли авангарда может выступить любой яркий раздражитель сегодняшних элитистских вкусов, включая завтрашний «контр-авангард» художественного рынка.

Чтобы увидеть исторические корни раздвоения русской культуры на официальную и неофициальную, надо вспомнить, что в 1917-м году, после февральской революции были созданы первые русские профессиональные союзы. Художники всех стилей и направлений объединились в один Союз Работников Культуры. Но после того, как большевики разогнали делегатов Учредительного собрания и запретили опозиционные партии и прессу, все профсоюзы объявили всеобщую забастовку. Произошёл раскол, художники авангарда стали «шрейкбрехерами» и получили государственные посты и заказы. Непокорное руководство некоторых других профсоюзов, например, учителей и булочников, расстреляли по законам военного времени. Как сказал Ленин, мировая война стала перерастать в войну гражданскую.

Таким образом, в Советской России раздвоение искусства на официальное и неофициальное стало латентным продолжением знаменитой гражданской войны, эхом забытой всеми великой забастовки. В начале 30-х социалистический реализм победил.

Soviet elite. The majority of old-fashioned realist artists were the unofficial non-conformists starving in the underground during the short-lived revolutionary carnival. True, they took their revenge. After staging a 'palace coup' and seizing power, avant-garde artists existed on a diet of bread and water. We often forget today that the post-Revolutionary avant-garde and Soviet official realism were two sides of one coin, of one socialist utopia.

The 'Soviet experiment' provides a lesson in paradox: during historical periods of avant-garde elitism, the role of the true avant-garde may actually be played by any vibrant irritant of elite taste, including tomorrow's 'counter-avant-garde' of the art market.

In order to grasp the historical roots of Russian culture's division into official and unofficial, it should be recalled that the first Russian professional unions were established just after the February revolution in 1917. Artists of all styles and schools united into one Union of Cultural Workers. After the Bolsheviks disbanded the Constituent Assembly and forbade opposition parties and press, all the unions went on strike. A split took place: the avant-garde artists became 'strike-breakers' and were given government positions and commissions. The recalcitrant leaders of several other unions, teachers and bakers, for example, were executed. As Lenin said, 'world war has transformed into civil war.'

The division of Soviet Russian art into official and unofficial was a latent continuation of the civil war and an echo of the great, forgotten strike. At the beginning of the 1930s, 'Socialist Realism' won out. All artistic organizations were banned, and the avant-garde was exiled from Soviet museums into the underground; forbidden to exhibit, its works were not allowed to be reproduced in art magazines. Only the 'conceptual branch' of the Russian avant-garde remained – – but outside museum walls and exhibition halls. The red banners and slogans of Agitprop openly survived on the streets throughout the Stalinist period. Thus, official art was further divided into the art of the elite and the mass art of the people. For many years no one realized that in the 20th century USSR, within the framework

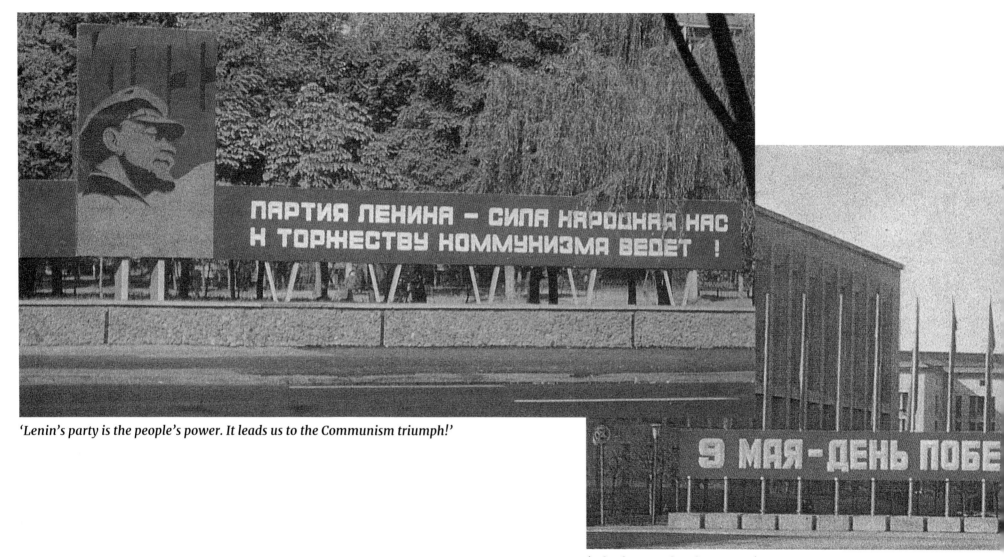

'Lenin's party is the people's power. It leads us to the Communism triumph!'

'9th of May – the Victory Day'

*Official Soviet
propaganda
of the 1970s*

'The power of Soviet society is in the unity of Party and people!'

Авангард был изгнан из советских музеев в подполье. Его выставки были запрещены, работы не репродуцировались. Вне музейных и выставочных стен осталась только одна «концептуальная ветвь» русского авангарда – красные лозунги Агитпропа, которые открыто пережили сталинские времена на улицах. Так произошло дополнительное раздвоение официального искусства на элитарное и массовое. Мы долго не понимали, что в 20-м веке в СССР в рамках тоталитарного Арт-деко существовал не только всем известный музейный соцреализм, но и «официальный концептуализм». Историки искусства так же долго не замечали его, как не замечали уличное искусство западной рекламы до появления поп-арта, который соединил массовое и элитарное, поместил поп-образы в музейный контекст.

После смерти Сталина «неофициальные художники» постепенно начали выглядывать из подполья. Как и все тираны, Сталин был недальновиден. Он не понял, что, захватив пол Европы, впустил за железный занавес Троянского коня. Вместе с Хрущёвской оттепелью в Москве появились югославские, польские, венгерские, чешские, болгарские, румынские, албанские и немецкие книги и журналы по искусству. На меня и моих друзей они оказали не меньшее влияние, чем идеи пражской весны на Михаила Горбачёва и других активистов перестройки.

Во времена моей юности художников второго авангарда, частью которых был и я, называли «нонконформистами» и даже «диссидентами», а наше искусство – подпольным и неофициальным. Но, несмотря на это, когда я учился в Строгановском Художественном Училище, работы некоторых неофициальных художников начали появлятся на официальных выставках. Этот процесс был остановлен в 1962 году на выставке в московском Манеже, где произошло столкновение Никиты Хрущёва и скульптора Эрнеста

of totalitarian Art-Deco, there existed not only official 'Socialist Realism', but 'official conceptualism' as well. The latter was not acknowledged by art historians for decades, just as the street art of western advertising was not recognized until the arrival of Pop art, which unified mass and elite art, placing popular images in a museum context.

Like all tyrants, Stalin was short-sighted. The dictator had not understood that in seizing half of Europe, he had actually led a Trojan horse in behind the Iron Curtain. After his death, 'unofficial artists' gradually began to peek out from underground. During Khrushchev's thaw, Yugoslavian, Polish, Hungarian, Czechoslovakian, Bulgarian, Rumanian, Albanian and German art books and magazines appeared in Moscow. They had no less an influence on my friends and myself than the ideas of the Prague Spring had on Mikhail Gorbachev and other *perestroika* activists.

During my youth, artists of the second avant-garde, to which I belonged, were called 'non-conformist' and even 'dissident'. Our art was termed underground and unofficial. Despite this, when I studied at the Stroganov Art Institute, the art works of a few unofficial artists began to appear in official exhibitions. This process came to an abrupt halt in 1962 at a huge exhibition in Moscow's Manège, when there was a confrontation between Khrushchev and the sculptor Ernst Neizvestny. After that, public poetry readings at the monument to Mayakovsky were forbidden as well.

2. Sots-art and the motivation of the unofficial artist.

After Leonid Brezhnev came to power, Russian art entered a new stage. At the beginning of the 1970s 'Sots-art' appeared—a conceptual movement that united unofficial and official art for the first time. ['Sots-art', *A Dictionary of Twentieth-Century Art,* by Ian Chilvers, Oxford University Press, 1998.) This method was apparent not only in Russian art, but later in Chinese art as well. Sots-art combined the conceptual branch of the Russian avant-garde—the banners and slogans of Agitprop - – with a dangerous nonconformist gesture. It filled Socialist Realist form

Неизвестного. Затем запретили публичные поэтические чтения у памятника Маяковскому.

2. Соц-арт и мотивация неофициального художника.

После прихода к власти Леонида Брежнева в русском искусстве начался новый этап. В начале 70-х появился «соц-арт» – концептуальное течение, которое впервые объединило неофициальное и официальное искусство («Sots-art», A Dictionary of Twentieth-Century Art, by Ian Chilvers, Oxford University Press, 1998). Влияние этого метода видно в творчестве многих, не только русских, но и китайских художников. соц-арт соединил концептуальную ветвь русского авангарда – лозунги Агитпропа – с опасным нонконформистским жестом. Наполнил форму социалистического реализма опозиционным содержанием. Это находка стала своеобразным творческим методом, самовыражением фундаментального дуализма и концептуальной эклектики нашего сознания.

В отличие от западного поп-арта, соц-арт был ближе к концептуализму. Если поп-арт был порождён перепроизводством товаров и их рекламы, соц-арт был порождён перепроизводством советской идеологии и её пропаганды. Сегодня, после многих лет жизни в Нью-Йорке я могу назвать западную рекламу «пропагандой консьюмеризма», а советскую пропаганду – «рекламой идеологии».

Как один из создателей соц-арта, я хочу поделиться своим видением некоторых психологических мотивов независимого творчества в условиях советской цензуры и отсутствия капиталистического рынка. В этом тексте я сознательно смешиваю местоимения "я" и "мы" не только потому, что в те годы работал в соавторстве с Александром Меламидом, но и потому, что участие художника в любом движении, или течении, или стиле всегда есть одна из форм неосознанного соавторства.

with the content of opposition. This unusual creative approach was an expression of the fundamental duality and conceptual eclecticism of our consciousness.

Sots-art was closer to conceptualism than Pop art was. If Pop art was resulted from the overproduction of goods and advertising, Sots-art emerged from the overproduction of Soviet ideology and its visual propaganda. Having lived in New York for many years now, I see western advertising as 'consumerist propaganda' and Soviet propaganda as 'ideological advertising'.

As one of the founders of Sots-art, I would like to share my view of some of the psychological motives driving independent artistic creation, when Soviet censorship reigned and there was a total absence of anything resembling a capitalist market. In this text the pronouns 'I' and 'we' are deliberately interchangeable – not only because, at the time, Alexander Melamid and I were co-artists, i.e. worked together as a single entity, but also because any artist's participation in a movement or style is always a form of unconscious collective authorship.

At the time, our criteria for gauging the success of our art had nothing to do with making a career, no matter what the price. Most important to us was fulfilling our fantasies of freedom and independence. In trying to do this, we created our own curtain inside the Iron Curtain. It was an ephemeral curtain delineating a bohemian ghetto: a fragile model of the provincial eccentric's behaviour in a totalitarian society. It was an attempt to preserve a mythological, almost perverse loyalty to our principles and image of self-worth. We were all attached to the old-fashioned, romantic notion of the 'unacknowledged genius'.

Inevitably, this drew us into a dangerous game with the 'censor as a viewer' and with 'the viewer as censor'. Visual metaphors became protective masks as well as allegories. The 'carnival' we created both mixed and juxtaposed form and content, parody and travesty, context and subtext. Our work was the development of our own artistic biography, and of

Мы понимали свой успех не как тактику делания карьеры любой ценой. В первую очередь, мы пытались удовлетворить свои фантазии о свободе и независимости. Внутри железного занавеса мы создавали ещё один занавес, эфемерный занавес богемного гетто, хрупкую модель поведения провинциального эксцентрика в тоталитарном обществе. Это была попытка сохранить мифологическую, граничащую с гротеском верность своим

принципам и критериям самооценки, в которых проявлялась привязанность к старомодной романтической концепции образа жизни «непризнанного гения».

Всё это вовлекало нас в неизбежную и опасную игру с «цензором как зрителем» и со «зрителем как с цензором». Визуальные метафоры превращались в защитные маски и аллегории. В этом карнавале постоянно происходило то противопоставление, то смешение формы и содержания, пародии и травестии, контекста и подтекста. Творчество становилось развитием авторской биографии творца и нашего общего исторического контекста. При этом предполагалось, что «историческая ценность» рано или поздно становится ценностью эстетической. Жизнь автора понималась как произведение искусства, как «романизация» образа жизни художника. В 1973-м мы создали двух художников: их работы, биографии, письма, документы и т.д. Один – Аппелес Зяблов – был первым абстракционистом, жил в 18-м веке и, протестуя против официального академического искусства, повесился. Жизнь второго – Николая Бучумова – была не менее драматична: в споре с левым авангардистом ему выбили глаз; с тех пор он покинул Москву и стал пейзажистом-отшельником, который всегда видел и всегда изображал в левой части своих картин свой нос.

Мы понимали своё творчество как создание сверх-концептуальной исторической работы, главный материал которой не только фотография, живопись, инсталляция или перформанс, а – время.

our common historical context. At the same time, it was assumed that 'historical value' would sooner or later become aesthetic value. The artist's life was seen as a work of art, as the 'novelization' of the artist's life. In 1973 Alex Melamid and I created two artists: their paintings, biographies, letters, documents concerning them, and so forth. One of them, Appeles Ziablov, was the first abstract painter. Ziablov was a serf who lived in the 18th century; in protest against the style of the official Academy of Arts that he was forced to conform to, he hung himself. The life of the second artist, Nikolai Buchumov, was no less dramatic. An argument with a left-wing avant-garde turned into a fistfight and the artist punched him, leaving him blind in his left eye. Buchumov then left Moscow and lived the life of a hermit; he painted landscapes, and as a true realist he faithfully depicted his nose on the left side of his paintings.

We saw our art as creating a conceptual history; our materials were not only photography, painting, text, installation and performance – but time itself. The contextual process of art's creation was the more important in our evaluation of our work than the finished artwork itself. It seemed to me that the era of class struggle had mutated into an era of the struggle between contexts.

The Russian avant-garde called for Alexander Pushkin to be thrown off the ship of modernity. But I think that the following lines from Pushkin's own poetry actually shed light on the avant-garde's most secret desire:
All that threatens us with peril,
An inexplicable pleasure does hold …
For the hearts of mortals.
As I have already said, our art led to a dangerous opposition to totalitarian censorship. In effect, our art was a manifestation of the self-destructive impulse of the subconscious. The Russian characters in Sacher-Masoch's novels made it clear that there is no contradiction between hedonism and the desire for self-destruction. In this light, today we can see Van Gogh's suffering and suicide as a travesty of the 'crucified artist'. Both

Игровым объектом оценки становилась не столько сама работа, сколько контекст процесса её создания. Мне казалось, что классовая борьба мутировала, начинается эпоха борьбы контекстов.

Русские авангардисты призывали сбросить Александра Пушкина с корабля современности. Но возможно, именно эти строчки его поэзии приоткрывают самую важную тайну авангарда:

Все, все, что гибелью грозит,

Для сердца смертного таит

Неизъяснимы наслажденья…

Как я уже говорил, наше искусство вело к опасному противостоянию тоталитарной цензуре. Оно становилось особой формой проявления саморазрушительных импульсов подсознания. Русские герои романов Захира Мазоха открыли западному миру, что стремление к саморазрушению не противоречит гедонизму. Теперь мы можем увидеть страдания и самоубийство Ван Гога как травестию «распятого творца». Оба были признаны при жизни только в узком кругу. Не случайно в молодости этот художник был проповедником. Отрезав себе ухо, он бессознательно повторил действие святого Петра, отрезавшего ухо стражнику в Гефсиманском саду. Великий Винсент стал стражником и апостолом одновременно, саморазрушительным врагом и последователем самого себя. В связи с этим мне кажется, что одним из ранних аналогов неофициального искусства была катакомбная культура древнего Рима. Таинственный «инстинкт саморазрушения» парадоксально многолик: от альтруизма до мазохизма, от самопожертвования во имя детей или идей до алкогольного нонконформизма или наркомании.

3. Бульдозерная выставка и кульминация неофициального искусства.

Квартирные выставки стали уникальной находкой второго авангарда. Весной 1974-го года на одной из таких выставок во

Christ and Van Gogh were recognized only by a narrow circle of followers during their lifetimes. It is no coincidence that Van Gogh was a preacher in his youth. When he cut off his ear, he was subconsciously repeating the action of Saint Peter, who, according to the Gospel of John, cut off the ear of the high priest's guard in the garden of Gethsemane. The great Vincent thus saw himself as the guard and the apostle simultaneously. He was the self-destructive enemy and his own follower at the same time. And in this regard, I believe that one of the earliest analogies to unofficial art is the catacomb art culture of ancient Rome. Paradoxically, the mysterious 'self-destructive instinct' is many-faceted: it can manifest itself as altruism, masochism, self-sacrifice in the name of ideas or children, as well as in alcoholism or drug addiction.

3. The Bulldozer exhibition and the Apogee of Unofficial Art.

Apartment exhibitions were unique to the second Russian avant-garde. In the spring of 1974, at one of those 'apartment exhibitions', during a Sots-art performance, everyone was arrested, including the veteran unofficial artist Oskar Rabin, and myself. We were interrogated all night. Unable to find anything criminal in our actions, the police released us the next morning. Much as they wanted to, the authorities could find nothing objectionable in the performance. The performance was noisy— Soviet marches were played, and my colleague Alex Melamid and I, playing Stalin and Lenin, shouted commands into a microphone to artists on a stage. Under our direction they created a huge Socialist Realist canvas depicting the heroic labour of Soviet workers. When there was an unexpected knock on the door and the police appeared, the audience initially laughed – people thought that this was part of the performance.

A few days after the arrests, Oskar called me and proposed repeating the performance at the apartment of his friend, the poet Alexander Glezer. This time the performance proceeded without any brouhaha and we began

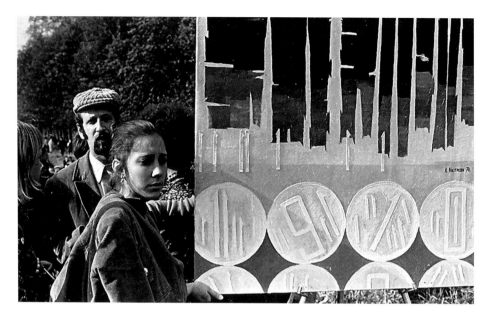

Bulldozer exhibition: Photographs from a private archive of Mikhail Abrosimov, first published in Iskusstvo *magazine in 2013, Courtesy of the Calvert Journal, www.calvertjournal.com*

время соц-артистского перформанса все зрители и участники были арестованы, включая ветерана неофициального искусства Оскара Рабина и меня. Нас допрашивали всю ночь и, не найдя ничего криминального, выпустили на следующее утро. Власти хотели, но не смогли придраться к идее перформанса. Перформанс был шумным: звучали советские марши, мой соавтор Алик Меламид и я играли роли Сталина и Ленина, кричали в микрофон команды находящимся на сцене художникам. Под нашим руководством они создавали большой холст социалистического реализма с изображением героического труда советских рабочих. Когда неожиданно раздался стук в дверь и появились представители власти, зрители сначала смеялись – они думали, что это часть перформанса.

Через несколько дней после ареста Оскар позвонил мне и предложил повторить перформанс на квартире своего друга, поэта Алексагдра Глейзера. На этот раз перформанс прошёл без скандала, и мы начали обсуждать новые пути показа наших работ, но не в галереях, куда неофициальное искусство не пускали, а под открытым небом. Мы поверили, что власти меняют своё отношение к художникам. Я даже написал проект создания второго, альтернативного союза художников. Позднее этот проект осуществился, но сначала, через несколько месяцев после перформанса разразился новый скандал – «Бульдозерная выставка», ставшая кульминацией истории неофициального искусства. 15 сентября 1974-го года в московском парке Беляево власти уничтожили работы многих художников, включая работы Оскара Рабина, Лидии Мастерковой, Евгения Рухина, Владимира Немухина, Александра Меламида и мои. Сегодня мало кто может вообразить сенсационный поток мировой прессы, вызванный этим скандалом. Я не могу забыть слова легендарного обозревателя Би Би Си Максима Гольдберга:

to discuss new ways of showing our art. We couldn't use the exhibition halls; unofficial art was not allowed there. But the great outdoors seemed possible. We believed that the authorities were changing their attitude toward artists. I even wrote a proposal for the creation of a second, alternative artists union. Though this project eventually came to be, there was dramatic public outcry just months after the performance. The 'Bulldozer Exhibition' became was the apogee of unofficial art's history. On 15 September, 1974, in the Moscow park Belyaevo, the authorities destroyed art by many unofficial artists, among them Oskar Rabin, Lidia Masterkova, Evgeny Rukhin, Vladimir Nemukhin, and Alexander Melamid and me. Today, few people can imagine the sensational flood of international press this confrontation elicited. I will never forget the words of the legendary BBC commentator Maksim Goldberg: 'Many bureaucrats in the west would love to send bulldozers out to destroy contemporary art, but the laws of the land don't allow them to.'

When I saw the bulldozers heading our way, any illusions I may have entertained regarding Soviet law disappeared instantly. I watched in a trance as people in plain clothes destroyed our art and professionally beat and arrested whoever resisted them. I froze. But when they knocked me down into the autumn mud and grabbed my painting *Double Self-Portrait: Komar and Melamid as Lenin and Stalin*, my fear vanished. A number of our Sots-art pieces had already been mangled, but the *Self-Portrait* was particularly important to me. When one of them stepped on the picture, intending to smash it, I suddenly imagined that it was a self-portrait of us not as Lenin or Stalin, but as Tolstoy or Gandhi. I raised my head, and quietly, in a trusting voice, said: 'What are you doing? This is a masterpiece!' Our eyes met and a different sort of contact arose inexplicably. Perhaps on hearing the word 'masterpiece' he remembered something long forgotten. I don't know, but he didn't smash the work, he simply tossed it into the back of a truck. A moment later, still lying in the mud, my eyes followed the garbage-filled truck as it drove off into history. I

Komar and Melamid

The Origin of Double Self-Portrait (Lenin and Stalin), 1974

Oil on canvas

Courtesy of Ronald Feldman Fine Arts, New York

Komar and Melamid

Double Self-Portrait, 1973

Oil on canvas

36 inches in diameter

Photo: Hermann Feldhaus

Courtesy of Ronald Feldman
Fine Arts, New York

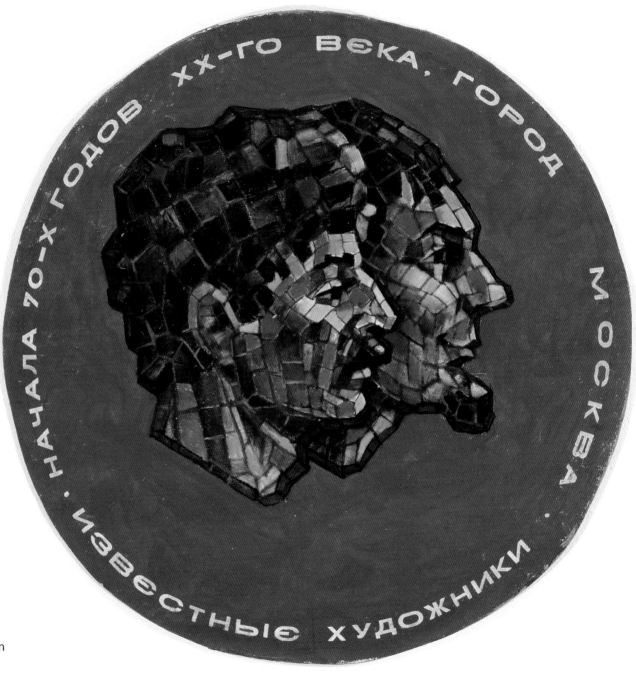

«На западе многие чиновники с удовольствием послали бы бульдозеры против современного искусства, но законы не позволяют им это сделать».

Когда я увидел бульдозеры, мои последнии иллюзии относительно законов изчезли. Как во сне я смотрел на людей в штатском, которые ломали наши работы и профессионально били и арестовывали тех, кто оказывал им сопротивление. Я окаменел, но когда они повалили меня в осеннюю грязь и стали вырывать из моих рук мой «Двойной автопортрет с Меламидом в виде Ленина и Сталина», страх исчез. До этого они уже исковеркали несколько работ нашего соц-арта, но этот «Автопортрет» был мне особенно близок. В тот момент, когда один из них наступил ногой на оргалит и хотел сломать его, я представил себя не в виде Ленина или Сталина, а в виде Толстого или Ганди. Я поднял голову и тихо, с доверительной интонацией сказал: «Ты что? Ведь это – шедевр!» Наши глаза встретились, и между нами возник какой-то необъяснимо «иной» контакт. Может быть, при слове «шедевр» он вспомнил что-то давно забытое? Не знаю, но эту работу он не сломал, а просто бросил её в кузов грузового автомобиля. Минутой позже всё ещё лёжа в грязи я проводил глазами удаляющийся в историю грузовик с мусором и улыбнулся. Может быть, это был мой «звёздный час»? Может быть, каждый художник втайне мечтает о том, чтобы его работа была уничтожена зрителем?

Теперь вы понимаете, почему я не собираюсь делать раскопки московской помойке в слоях 70-х годов конца второго тысячелетия?

Как и все художники авангарда, мы мечтали сломать барьер между собой и зрителями, но парадокс был в том, что сначала мы сами этот барьер создавали, т.е. создавали свои работы. И вот зрители сами сломали этот барьер, когда мы пошли к ним на встречу. Это была такая же форма соавторства, как разрушение греческих статуй христианами, как разрушение христианских храмов Лениным, как иконоклазм русских диссидентов, разрушающих статуи Ленина.

smiled. Was this my 'finest hour'? Maybe every artist secretly dreams of his work being destroyed by the viewer?

As you can well imagine now, I have no intention of excavating the layers of 1970s Moscow landfill to find it.

Like all avant-garde artists, we dreamed of breaking down the barrier between art and its audience, but the paradox was that at first we erected this barrier ourselves, by the very act of creating our works. At the *Bulldozer Exhibition*, as we advanced to meet them halfway, the audience (in this case the KGB) had literally broken down the barrier,. It was the same form of collaboration as the destruction of Greek statuary by the Christians. Or Lenin and Stalin's destruction of Christian churches. Or the iconoclasm of Russian dissidents who wanted to destroy statues of Lenin.

The unbearable feeling of isolation made us leave the underground for the streets in search of an audience. Today many people have forgotten that the Soviet state owned everything: the army, the secret police, all the banks, offices, buildings and supermarkets. It also owned all the galleries, museums, exhibitions, art magazines, the entire press, all the film studios, all the radio stations and television channels. Therefore, unofficial artists could only work in the very rooms and cellars where they lived. In these living spaces we showed our art to a narrow circle of friends and acquaintances. We often drank all night, arguing about art and reciting poetry. Kitchen discussions substituted for the absence of freedom of speech and reviews by art critics. The idea of showing our art outdoors was born on one such evening at Oskar Rabin's apartment. Something that the west might see as a commercial gesture (an outdoor show) was an avant-garde gesture in Russia. For a time I believed that the air wasn't the property of the bureaucracy.

Artists of varying styles participated in the *Bulldozer Exhibition*, but unfortunately not all our friends and colleagues supported us. For example, the artist Ilya Kabakov declined to participate a week before the exhibition. Speaking to Oskar, Ilya said that he'd been standing on all fours his entire

Именно поиск зрителя и невыносимое чувство одиночества заставили нас выйти из подполья на улицу. Сегодня многие уже не помнят, что советскому государству принадлежали не только армия, тайная полиция, все банки, офисы, дома и супермаркеты. Ему так же принадлежали все галереи, музеи, выставки, художественные журналы, вся пресса, все киностудии, все радиостанции и каналы телевидения. Поэтому неофициальные художники работали в тех же комнатах и подвалах, где и жили, и там же мы показывали свои работы узкому кругу друзей и знакомых. Всю ночь мы могли пить, спорить об искусстве и читать стихи. Дискуссии на кухне заменяли нам отсутствие свободы слова и рецензии художественной критики. Вот именно в одну из таких ночных дискуссий на квартире Оскара Рабина родилась идея показать наши работы под открытым небом. То, что на западе считалось признаком коммерческого искусства, в России стало авангардным жестом. На какое-то время я поверил, что воздух не является собственностью бюрократии.

В «Бульдозерной выставке» участвовали художники разных индивидуальных стилей, но, к сожалению, не все друзья и коллеги поддержали нас. Например, художник Илья Кабаков за неделю до выставки отказался в ней участвовать. Обращаясь к Оскару, Илья сказал, что всю свою жизнь стоит на четвереньках, а открытый выход из подполья на улицу – это позиция человека, стоящего на двух ногах. Затем он посмотрел на нас с Аликом и добавил: «Или на руках, как эти юные дадаисты…» Сегодня я не осуждаю этот «метафорический цинизм». Все издательства принадлежали государству и, как член официального союза художников, Илья зарабатывал на жизнь, иллюструя советские книги для детей. Эта двойственность была в разной степени типична для многих из нас. Исходя из своих принципов, мы становились профессиональными художниками «выходных дней». Например, я давал уроки рисования, готовил частных учеников к поступлению в художественные институты

life, and leaving the underground for the street was the gesture of a man who stood on two legs. Then he looked at Alex and me and added '… or on two hands, like these young Dadaists…' I cannot pass judgment on this 'metaphorical cynicism'. All of the publishing houses belonged to the state and as a member of the official artists union, Ilya earned his living by illustrating children's books. A kind of duplicity or dualism was typical of many of us, to varying degrees. Depending on our principles, we became 'weekend' professional artists. For example, I gave drawing lessons and privately tutored students to take the entrance exams for the art institutes (in the USSR education was free, which meant the competition was fierce). Once I even designed a camp for Young Pioneers. Such contradictions were manifested not only in our life style, but in our art.

Until the end of the 17th century, an original and colourful version of canonic Eastern Orthodox icon painting flourished in Russia. Subsequently, Peter the Great's reforms in the early 18th century brought western Renaissance traditions to Russia, with their three-dimensional spatial perspective and realistic treatment of light and shade. But in folk art the love of ancient Russian traditions remained; their two-dimensional treatment of colour and form contrasted with the three-dimensional treatment of space. In some 19th century Russian cathedrals I have seen a unique dialectic of eastern and western styles. Two-dimensional planes and three dimensional depth. Faces and wrists are painted in a realistic academic manner, but the background and clothes are rendered in the style of medieval icons.

A similar conceptual eclecticism is apparent in some of the most original works of Soviet art in the period of 'totalitarian art-deco', and during the transition from the avant-garde to Socialist Realism. Again, the faces and hands are painted realistically, while the background and clothes are rendered in a cubo-futuristic style.

The source of this dualism lies not only in Russia, which is located on the border of two continents, and the cultural traditions of Europe and Asia.

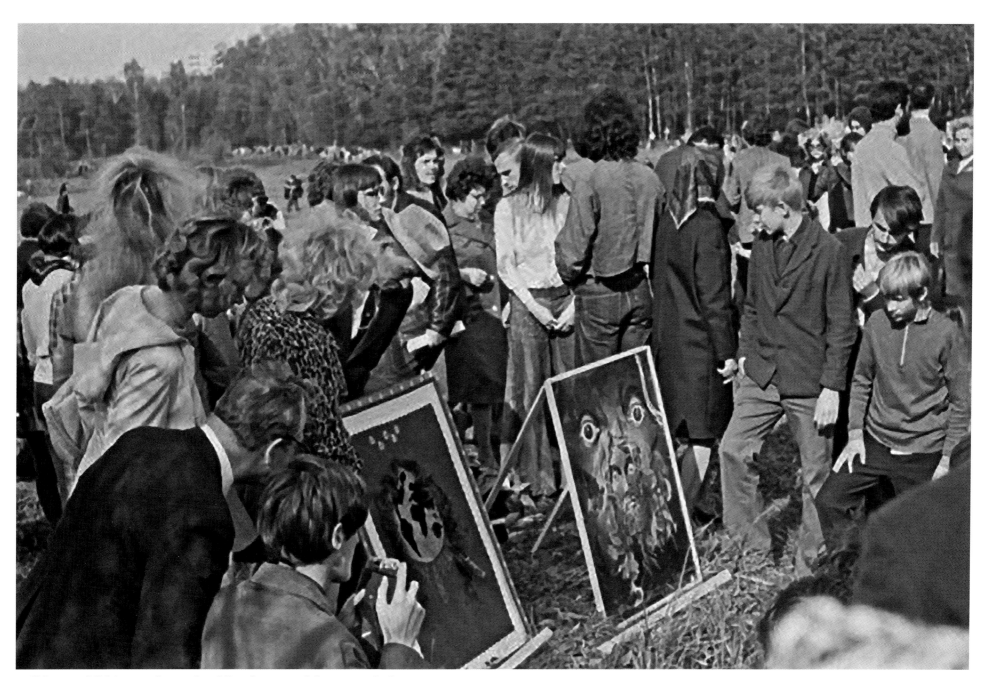

Bulldozer exhibition: Artists and public. Photograph by Igor Palmin

(образование в СССР было бесплатным, что порождало безумные конкурсы). Однажды я даже оформлял пионерский лагерь. Эти противоречия и двойственность проявлялись не только в стиле нашей жизни, но и в стиле нашего искусства.

До конца 17-го века в русской живописи процветало оригинальное и красочное развитие византийских канонов восточной иконописи. Затем реформы Петра Первого принесли в Россию западные традиции Возрождения с его трёхмерной пространственной перспективой и реалистической светотенью. Но в народном творчестве сохранялась старая любовь к древнерусским традициям, к двумерной трактовке цвета и формы, которая противоречила трёхмерной трактовке пространства. В некоторых русских соборах 19-го века я вижу уникальную диалектику восточного и западного стилей, двухмерной плоскости и трёхмерной глубины. Лица и кисти рук написаны в реалистическом стиле академии, а фон и одежды – в стиле средневековой иконы.

Сходная концептуальная эклектика видна и в некоторых наиболее оригинальных работах советского искусства в период «тоталитарного арт-деко» при переходе от авангарда к соцреализму. Опять лица и руки написаны в реалистическом стиле, а фон и одежды – в стиле кубофутуризма.

Истоки этого дуализма не только в России, которая находится на границе двух материков и культурных традиций Европы и Азии. Двойственность универсальна. Во времена раннего Возрождения мы видим её и в искусстве Северной Европы, и на юге, в Италии. Она – проекция изначальной двойственности человечества, разделённого на мужчин и женщин.

В неофициальном искусстве в начале 70-х Оскар Рабин сделал живописные копии своего советского паспорта: на большом холсте он соединил концептуализм с экспрессионизмом. Тогда же другой выдающийся неофициальный художник Олег Васильев стал соединять

Duality is universal. During the early Renaissance we see it in the art of Northern Europe, and in the south in Italy. It is a projection of humanity's basic duality, the division into male and female.

Many works of unofficial Russian art were ahead of their time, and were forerunners of what came to be called 'postmodernism' and the 'transavantgarde' in the 1980s. At the beginning of the 1970s, Oskar Rabin painted a portrait of his Soviet passport: on a large canvas, combining conceptualism with expressionism. At the same time, another outstanding unofficial artist, Oleg Vassiliev, began to combine geometric abstraction with postimpressionism. In 1972, in Sots-art, we (Komar and Melamid) combined two styles: 'unofficial and official', 'private and public', 'introvert and extravert', for the first time, and also used a significantly larger number of 'multi-faceted' styles and concepts than had been done before. At that time I realized that all individuals, in one way or another, become part of a collective historical style. We viewed the history of art as a dictionary of intonations. In works such as *Heinrich Böll's Meeting with Solzhenitsyn at Rostropovich's Dacha*, in our installation *Paradise*, in the polyptych *Biography of a Contemporary*, in our 'Post-Art' project, and others, we reflected the multi-stylistic, conceptually eclectic consciousness of the Soviet Union's second avant-garde.

June 2016

Translated from the Russian by Jamey Gambrell

геометрические абстракции с постимпрессионизмом. В 1972-м году
в своём соц-арте мы (Комар и Меламид) впервые начали соединять
не только два стиля – «неофициальное и официальное», «личное
и социальное», «интровертное и экстравертное», – но значительно
большее количество «многомерно увиденных» стилей и концепций.
В те годы я увидел, что любая индивидуальность так или иначе
становится частью коллективного исторического стиля. Мы поняли
всю историю искусства как словарь интонаций. В таких работах,
как «Встреча Бёля с Солженицыном», в инсталляция «Рай», в
полиптихе «Биография современника», в проекте «Пост-Арт» и
т.д., мы отражали мультистилистику
 и концептуальную эклектику сознания второго авангарда в
Советском Союзе.
 Многие работы неофицального русского искусства опередили
своё время, были предвидением того, что в 80-х стали называть
«постмодернизмом» и «трансавангардом».

Bulldozer exhibition: Works
by Lydia Masterkova and
others destroyed.
Photograph by Igor Palmin

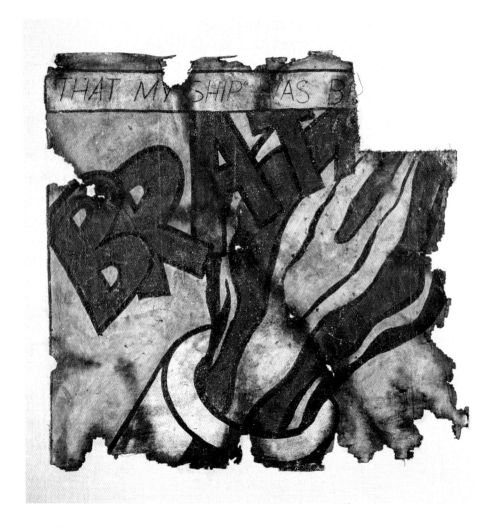

Komar and Melamid

Post-Art No. 1 (Warhol), 1973

Oil on canvas

48 x 36 inches

Photo: Casey Dorobek

Courtesy of Ronald Feldman
Fine Arts, New York

Komar and Melamid

Post-Art No. 2 (Lichtenstein), 1973

Oil on canvas

42 x 42 inches

Courtesy of Ronald Feldman
Fine Arts, New York

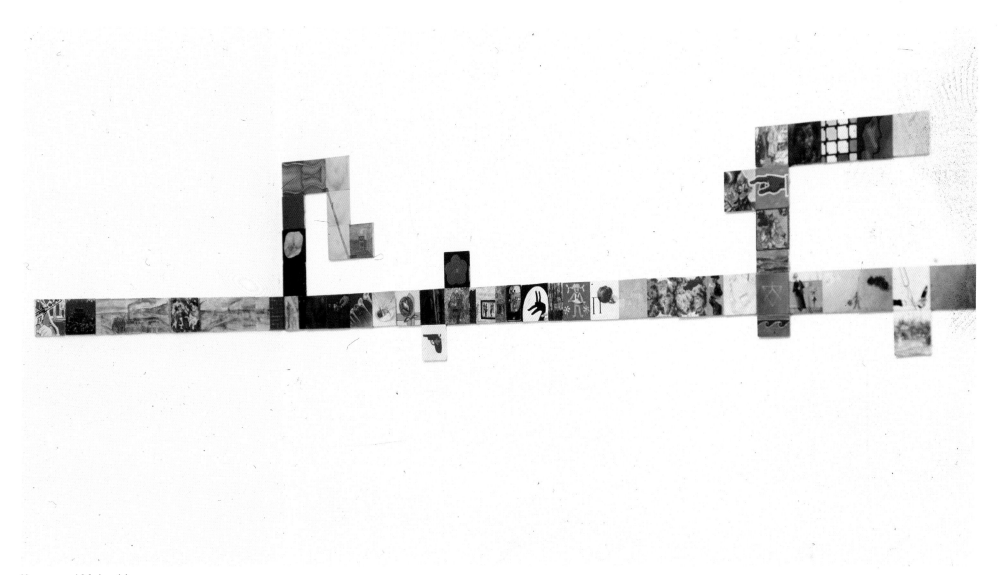

Komar and Melamid

Biography of Our Contemporary, 1972-73, 197 panels (detail)

Collection Robert & Maryse Boxer, London

Photo: Stephen White

Courtesy of Ronald Feldman Fine Arts, New York

KOMAR AND MELAMID

Timeline

1943

(September 11) Vitaly Komar born in Moscow, Russia to a family of lawyers; his mother is Jewish and his father is Christian. In the first few years of his life, Komar is raised with a Jewish background by his grandfather.

1945

(July 14) Alexander Melamid born in Moscow, Russia, into a Jewish family; his mother, Ludmila Cheurnaya, was a publicist and translator. His father, Daniil Melamid (also known as D.Melnikov), was a history scholar.

1956-60

Vitaly Komar attends Moscow Art School

1958-62

Alexander Melamid attends Moscow Art School

1961

Vitaly Komar starts at Stroganov School of Art and Design

1962

Alexander Melamid starts at Stroganov School of Art and Design

1962-63

Vitaly Komar is drafted from Stroganov School of Art and Design to the army, where he made Socialist Realism paintings and slogans for the Military Sports Club

1963

They meet in an anatomy drawing class, at a Moscow morgue

1967

They graduate from the Stroganov Institute of Art and Design.

They exhibit works in a two-man show entitled *Retrospectivism* at Moscow's Blue Bird Café, on for one night only and admission by invitation only. It includes three-dimensional abstract paintings in the style of the old masters and reflects a typical search for spirituality on the part of non-conformist artists working in an oppressively atheistic state.

Vitaly Komar marries and has a son, Peter.

1968

They join the youth section of the Moscow Union of Artists.

They start teaching art and work freelance as designers: Melamid designs theatre sets in the far northern city of Arkangel'sk. Komar, and then Melamid, find work restoring church murals in Moscow.

1969

Alexander Melamid marries Katya Arnold and has two sons, Andrew and Daniel.

They start to face the first examples of political difficulties with their art when censors remove their work from the 8th Exhibition of Young Artists in Moscow.

1972

They have jobs at a children's camp near Moscow with an assignment to decorate the premises with paintings of Soviet heroes.

The Sots Arts movement is inaugurated.

1973

They fill a room in a Moscow apartment with their installation *Paradise*. "Samisdat" a self-published underground artist book named *Paradise* is made out of black and white photographs of the performance. It is demolished on state order in 1974.

They are expelled from the Youth Division of the Artists' Union, charged with the 'distortion of the Soviet reality and deviation from the principles of Soviet Realism'.

They paint *Double Self-Portrait* depicting their own profiles in a *faux*-Byzantine manner officially reserved for state leaders and decorated heroes.

1974

They are arrested for their performance *Art Belongs to the People*. This performance was later reprised at the Kitchen (New York, 1984) and at an arts festival (San Archangelo, Italy 1984).

They paint *Scenes from the Future: Guggenheim Museum* with the museum shown in ruins.

(15th September) They participate in the *Bulldozer Exhibition* organised by a Moscow artist named Oscar Rabin and held in a vacant field in Beljaevo, Moscow. A second show is held at Izmailovsky Park two weeks later.

1975

They work on a few different projects including the *Codes* series, *Prophet Obadiah* black and white photography polyptych and their first piece collaborating with the American artist Douglas Davis: *Where is the Line Between Us?* (Metropolitan Museum collection)

They paint the *History of the USSR* (from the *Ideological Abstractionism* series), polyptychs of fifty-eight panels, each twelve inches wide. Each inch represents a month, each panel a year, referring to the years since the 1917 revolution.

1976

Their first exhibition is held at Ronald Feldman Fine Arts, New York in February.

They renounce their Soviet citizenship one year before receiving exit visas and create their own state, Trans-State, including constitution, alphabet, language, passport, money, and a border post, discrete declaration of independence, constitution, currency, passports, and membership application to the United Nations.

1977

They apply for exit visas, and after their second request, are expelled from the Graphic Artists' Organisation.

(October) Alexander Melamid and his family immigrate to Israel

(December) Vitaly Komar immigrates to Israel

1978

They perform their first outdoor performance *The Temple of Komar and Melamid* on a hillside overlooking the Valley of Hinnom in Israel. A pyramid aluminium temple is built and then destroyed. They burn Vitaly Komar's suitcase in sacrifice.

(September) They arrive in New York. In the same month, their first museum show opens at Matrix 43, Hartford Athenaeum, Hartford, Connecticut.

They make their first sales to a museum.

They establish Komar and Melamid Inc. This is their first capitalist venture, to buy and sell souls, launching an advertising campaign, including posters and print adverts.

They make their first collaboration with animals, teaching Tranda, the dog, to draw.

1979

Souls are smuggled into USSR and sold at the *First Auction of American Souls in Moscow*. Andy Warhol's soul sells for 30 roubles.

1980

Together with students of the Massachusetts College of Art, Boston, and Charlotte Moorman, they create a series of installations and performances entitled *School of Revolution*.

1981

Portrait of Hitler is slashed at *Monumental Show* in Brooklyn, New York. The damage is inflicted by an ex-Trotskyite disk jockey, but the Jewish Defence League takes the credit. They do not repair the canvas, recognizing the vandal as co-author.

1982

The *Sots Art* show at the Feldman gallery is a success. Within a year, the 'Nostalgic Socialist Realism' series painting: *I Saw Stalin Once When I Was a Child* is acquired by the Museum of Modern Art, New York; and *Blindman's Buff* is acquired by the Metropolitan Museum of Art, New York.

They are the first Soviet artists to receive a grant from the National Endowment for the Arts.

1983

They create a poster for the New York City subway system, *Thank You Comrade Stalin for Our Happy Childhood*, as part of the Subculture project organised by Group Material.

1984

They move their studio to Canal Street in Chinatown.

They give their first European performances in Saint Arcangelo, Italy and Rotterdam.

1985

The Yalta Conference, a mural project for the United Nations building, is approved and financed by City Art Inc., New York, but is banned by the Community Board.

They participate in the *Alles und noch veil Mehr,* curated by Jean-Hubert Martin, at the Kunsthalle and Kunstmuseum, Bern, Switzerland. This is their first major international group exhibition.

1986

They participate in The Biennale of Sydney, Australia.

They create their first public sculpture commissioned by the Hague's Geneentemuseum (Netherlands) for the city's red light district: an installation with bronze *Bust of Stalin and Herring,* inside of a public phone/safety booth.

1987

They are the first Russian artists invited to participate in the history of the *documenta* exhibitions.

They paint *Winter in Moscow 1977* and *Yalta 1945,* a large two-part environmental piece with a total of fifty-seven panels specifically for *documenta 8* (Kassel, West Germany)

1988

They become United States citizens.

They publish their first book as poets, *Poems About Death.*

1990

They exhibit their polyptychs *Yalta 1945* and *Winter in Moscow 1977* at Brooklyn Museum of Art, New York.

Bayonne, NJ, a series of polyptychs based on the life of workers at a brass foundry in Bayonne, New Jersey, is exhibited at FIAC, Paris (Montenay/Giroux Frederic Gallery).

1991-92

They create a series of religious works.

Their installation *Sears* is exhibited at Ronald Feldman Fine Arts, New York.

In connection with the disintegration of the Soviet Union, they begin the *Lenin Mausoleum* project.

1992

Monumental Propaganda is launched to coincide with beginning of the destruction of Socialist Realist monuments in post-Soviet Russia.

At Komar and Melamid's invitation, published in *Artforum* magazine (#9, 1992), more than two hundred Russian and Western artists create projects to preserve monuments.

Sots Art becomes an international movement.

1993

They perform a performance in Red Square on Lenin's birthday, 11 April – *Lenin's Mausoleum* installation

1994

Death and Immortality installation, Ronald Feldman Gallery, *New York. Suite in Chrome Yellow, series of 5* paintings (now in the collection of the Whitney Museum of American Art).

Artists create the series of books *Most Wanted and Most Unwanted* for *People's Choice* with the help of The Nation Institute and The Dia Foundation.

1995

They collaborate on abstract paintings with an African elephant at the Toledo Zoo, Ohio, in a project called *Ecollaboration*. Later, at the end of the 1990s, this event was transformed to the *Asian Elephant Art and Conservation Project (AEACP)*.

1997

They are invited by curator Germano Chelante to participate at the Armory Show at Venice Biennale.

They publish *Painting by Numbers*: *Komar and Melamid's Scientific Guide to Art*, Jo Ann Wypijewski, ed. (New York: Farrar, Strauss & Giroux, 1997). Includes essay by Arthur C. Danto.

They participate in *It's a Better World* at Wiener Secession, Austria, curated by Joseph Backstein & Johanna Kandl.

1997-98

They participate in the creation of the *Naked Revolution*, an opera about Washington, Lenin, and Duchamp created with David Soldier. The opera as well as a series of paintings, sculpture, and collages, becomes part of the *American Dreams* series (1996-1997), based on the artists' collection of George Washington memorabilia.

1999

They travel to Moscow to teach Mikki, a chimpanzee, to take photographs.

2000

(March) First ever auction of elephant paintings is held at Christie's, New York.

2002

Second Commandment, their reconstruction of the works of Dimitry Tveretinov, the first Russian conceptual artist, who lived at the beginning of the eighteenth century, is exhibited at Gelman Gallery, Moscow.

They put on the exhibition *Symbols of the Big Bang* at Yeshiva University Museum.

2003

They start to transform some of their *Symbols of the Big Bang* into stained glass for the international show: *Berlin-Moscow, Moscow-Berlin 1950-2000*.

Vitaly Komar and Alexander Melamid stop working in collaboration and continue with solo artistic careers.

Selected Exhibition History

1965
First collaborative lecture/performance, Academy of Art, Vilnius; Stroganov Institute of Art & Design, Moscow.

1967
Blue Bird Cafe (Moscow Institute for Art and Design), *Retrospectivisim*.

1968
Moscow Artists Union, *Eighth Show of Young Artists* (Komar and Melamid works censored by authorities).

1974
Outdoor exhibition, Belijaevo, Moscow, *The Bulldozer Exhibition*, September 15.
Outdoor exhibition at Izmailovsky Park, Moscow, September 29.

1976
Ronald Feldman Fine Arts, New York, *Color Is a Mighty Power!*. Music Writing: Passport, simultaneous performance, New York, many venues in the United States and Moscow.

1977
Ronald Feldman Fine Arts, New York, *TRANSSTATE*.
Ohio University Gallery of Fine Arts, Columbus, OH. Berry College, Rome, GA, September.

1978
White Gallery, Tel Aviv, Spring.
Wadsworth Atheneum, Hartford, CT, *MATRIX 43*. Ronald Feldman Fine Arts, New York, The Temple, Third Temple, outdoor performance, Jerusalem.

1979
Ronald Feldman Fine Arts, New York, Moscow, *We Buy and Sell Souls*, auction-performance.
The Hirshhorn Museum and Sculpture Garden, Smithsonian Institution, Washington, D.C., lecture-performance.

1980
Ronald Feldman Fine Arts, New York.
Edwin A. Ulrich Museum of Art, Wichita State University, Wichita, KS.

1981
Massachusetts College of Art, Boston, MA, (lecture-performance).
Museum of Contemporary Art, Chicago, (lecture-performance).

1982
Ronald Feldman Fine Arts, New York, *Sots-Art*.

1983
Portland Center for Visual Arts, Portland OR.
Anderson Gallery, Virginia Commonwealth University, Richmond, VA.

1984
Ronald Feldman Fine Arts, New York, *Business as Usual*.
Saidye Bronfman Center, Montreal.
Palace Theater of the Arts, Stamford, CT.
University of Iowa Museum of Art, Iowa City, IA.

1985
Swen Parson Gallery, Northern Illinois University, DeKalb, IL.
Ronald Feldman Fine Arts, New York, *New Paintings*.
Metropolitan Museum and Art Center, Coral Gables, FL, March.
CEPA Gallery, Buffalo, NY, May – June.
Fruitmarket Gallery, Edinburgh, and tour to the Museum of Modern Art, Oxford;.
Musee des Arts Decoratifs, Louvre, Paris, France;.
Arts Council Gallery, Belfast.

1986
Tyler School of Art, Temple University, Philadelphia, PA.
Ronald Feldman Fine Arts, New York, *Anarchistic Synthesism*.
Sable-Castelli Gallery, Toronto.
Van Straaten Gallery, Chicago.

1987
Artspace, Sydney, Australia, and toured to Institute for Modern Art, Brisbane; School of Art Gallery, University of Tasmania, Hobart; Australian Centre of Contemporary Art, Melbourne; Praxis, Perth; Experimental Art Foundation, Adelaide.
Ronald Feldman Fine Arts, New York, *Komar and Melamid*.
documenta 8, Kassel, West Germany.

1988
Kicken Pauseback, Cologne, West Germany.
Gallery Paule Anglim, San Francisco.
Van Straaten Gallery, Chicago, New Work.
Moriarty Gallery, Madrid, *Death Poems*, October.
Galerie Barbara Farber, Amsterdam. *A Diary's Pages 1985-1988*.
Neue Gesellschaft fur Bildende Kunst, West Berlin, *Death Poems*.

1989
Bowdoin College Museum of Art, Brunswick, ME, *Komar and Melamid*.
Ronald Feldman Fine Arts, New York, *Bergen Point Brass Foundry, Bayonne*.
University of North Texas, Denton, TX, *Russians in America*, organized by Exhibits USA and toured through 1990 to Sunrise Museums, Charleston, WV; Alaska State Museum, Juneau; Anchorage Museum of History and Art, AN; University of Alaska, Fairbanks, AN; Washington University, St. Louis, MO; Haggerty Museum of Art,

Marquette University, Milwaukee, WI.
Mandeville Gallery, University of California, La Jolla, CA,
Komar and Melamid:.
Recent Work Solo Gallery, New York, *Horn of Plenty*.

1990
Gallery 210, University of Missouri, St. Louis, MO,
Painting: 1980 to 1986.
Brooklyn Museum, New York, *Komar and Melamid
Yalta 1945 and Winter in Moscow 1977*, A *Grand Lobby
Project*.
South Campus Art Gallery, Miami Dade Community
College, Miami, FL, *Forty Monotypes*.
Fuller Elwood Gallery, Seattle, *In America*.
Vinalhaven Press, New York, *Hot Heavy Sears and The
Double Revelation*.

1991
Ronald Feldman Fine Arts, New York, *Paintings for the
Holy Rosary Church*.
Ljubljana Congress Center, Cankarjev Dom, Yugoslavia,
Komar and Melamid.
The University Gallery, Memphis State, Memphis, TN,
Komar and Melamid: Art/History.

1992
Ronald Feldman Fine Arts, New York, Komar and
Melamid: *Searstyle with Psalms*.

1993
Ronald Feldman Fine Arts, New York, *Death &
Immortality*.
Contemporary Art Centre, Guelman Gallery, Moscow,
The Stepped Pyramid with performance in Red Square,
Moscow: *What to do with Lenin's Mausoleum?*.

1994
Contemporary Arts Center/Guelman Gallery, Moscow,
People's Choice.
Alternative Museum, New York, *People's Choice* and

travelled through 1995 to: Washington Project for the
Arts, Washington, D.C. and Herbert F. Johnson Museum
of Art, Cornell University, Ithaca, NY.

1995
Dia Center for the Arts, New York, NY, located on the
Internet until 1996. Checkpoint Charlie, Berlin, Germany.
Storefront for Art & Architecture, New York, NY.
Henry Art Gallery, Seattle, Washington.
Ukrainian State Museum, Kiev, Ukraine.

1996
University of Michigan, Ann Arbor, MI.
Reijavik Municipal Art Museum, Reijavik, Iceland.

1997
Ronald Feldman Fine Arts, New York, NY, *American
Dreams*,.
Ludwig Museum of Modern Art, Cologne, Germany,
Komar and Melamid, Die Beliebten und Ungeliebten.
Bilder, Curated by Evelyn Weiss and Mark Scheps,
Kunsthalle, Rotterdam, Holland, *The Most Wanted – The
Most Unwanted Painting*.

1998
The Akron Art Museum, Akron, OH, *The People's
Choice*, and travelled through 1999/2000 to: Ilingworth
Kerr Gallery, Alberta College of Art and Design, Alberta,
Canada, Nevada Museum of Art, Reno, NE; Santa
Barbara Museum of Art, Santa Barbara, CA; Dunlop Art
Gallery, Regina, Saskatchewan, Canada; University of
Missouri-Kansas City Art Gallery, Kansas City, MS; Olin
Arts Center, Bates College, Lewiston, ME.
Kunsthalle, Vienna, Austria, *Komar and Melamid*, Schön-
Haslich, Curated by Gerald Matt.

1999
La Biennale di Venezia, Venice, Italy, Animal Kingdom,
*Elephant paintings and Mikki – chimpanzee's
photographs*; curated by Joseph Bakstein.

2001
Philadelphia Art Alliance, Philadelphia, PA, *American
Dreams*; curated by Ammy Schlegel.

2002
Yeshiva University Museum, Center for Jewish History,
New York, NY, *Symbols of the Big Bang*; curated by Reba
Wulkan and travel to: The Temple Judea Museum, Elkins
Park, PA.
Berkeley Art Museum, Berkeley, CA, *Komar and
Melamid's Asian Elephant Art and Conservation Project*.

2003
Kawamura Memorial Museum of Art, Chiba, Japan,
Komar and Melamid: Desperately Seeking a Masterpiece.

2005
Vitaly Komar's *Three-Day Weekend* is exhibited at Ronald
Feldman Gallery, New York (18 June – 29 July 2005); Ben
Uri, London (7 August – 4 September 2005); Matthew
Bown Gallery, London (August – September 2005);
Cooper Union for the Advancement of Science and Art,
New York (25 October – 11 December 2005).

2007
Second Moscow Biennale, March. Moscow, Russia.
Group show *Sots-Art*. New State Tretiakov Gallery,
Moscow.

2016
Ben Uri Gallery and Museum, London, UK, *Yalta 1945*

Selected Bibliography

Books and catalogues

Agamov-Tupitsyn V., *Bul'dozernaia vystavka = The Bulldozer Exhibition / english translation by KėtilAng*, (Moskva: Ad Marginem Press, 2014)

Agamov-Tupitsyn V., *The Museological Unconscious: Communal (Post) Modernism in Russia*, (Cambridge: MIT Press, 2009)

Andreeva E., *Sots art : Soviet artists of the 1970s and 1980s.*, (Craftsman House, 1995)

Baigell R., Baigell M. (ed.), *Soviet dissident artists: interviews after Perestroika*, (New Brunswick: Rutgers University Press, c1995)

Backstein, Joseph, *Glasnost: Soviet non-conformist art from the 1980s = Sovetskoe neofitsialnoe iskusstvo 1980-kh*, (London : Haunch of Venison, 2010)

Charles River Editors, *The Yalta Conference: The History of the Allied Meeting that Shaped the Fate of Europe After World War II*, (Charles River Editors, 2016)

Dodge, Norton, and Alison Hilton, *New Art from the Soviet Union: The Known and Unknown*, (Washington, D.C.: Acropolis Books Ltd., 1977)

Erjavec A., and Groys B., *Postmodernism and the Postsocialist Condition: Politicized Art Under Late Socialism*, (Berkeley: University of California Press, 2003), p. 55–89

Gamboni D., *The Destruction of Art: Iconoclasm and Vandalism since the French Revolution*, (London, Readktion Books, 1997)

Kruspit, Donald 'Komar and Melamid' in Goedl, M., Frohne, U., Nasgaard, R., *documenta 8*, (Kassel: Weber & Weidemeyer, 1987), p.132

Groys, B 'The Other Gaze Russian Unofficial Art's View of the Soviet World' in Erjavec A., and Groys B., *Postmodernism and the Postsocialist Condition: Politicized Art Under Late Socialism*, (Berkeley: University of California Press, 2003), p.55–89

Groys, B.,*The Total Art of Stalinism: Avant-Garde, Aesthetic Dictatorship, and Beyond*, (Verso: Reprint edition, 2011)

Harbutt, Fraser, *Yalta 1945 Europe and America at the Crossroads*, (New York: Cambridge University Press, 2010)

Hughes R., *Nothing If Not Critical*, (New York: Alfred A. Knopf, 1990)

Iampolski M., *Symbol and Origin, Fulcrum; an annual of poetry and aesthetics*, (Cambridge, 2003), p.315–332

Jackson M.J., *The Experimental Group: Ilya Kabakov, Moscow Conceptualism, Soviet Avant-garde*, (Chicago: University of Chicago Press, 2010)

Ratcliff, C., *Komar and Melamid*, (New York: Abbeville Press, 1989)

Nathanson, M.B. (ed.), *Komar / Melamid, Two Soviet Dissident Artists*, (Southern Illinois University Press, 1979)

Osborn P. (ed.), *Conceptual Art*, (London: Phaidon Press LTD, 2002)

Rapaport, B., K., *Komar and Melamid: Yalta 1945 & Winter in Moscow 1977: March 16 to June 4, 1990, a grand lobby project, The Brooklyn Museum*, (Brooklyn, NYC: The Brooklyn Museum, 1990)

Siegel L., *Falling Upwards, Essays in Defense of the Imagination*, (New York: BasicBooks, 2009)

Solomon A., *The Irony Tower: Soviet Artists in a Time of Glasnost*, (New York: Alfred A. Knopf, 1991)

Tupitsyn, M., 'Sots Art The Russian Deconstructive Force' in Tupitsyn, M., *Margins of Soviet Art*, (Milan, Italy, Giancarlo Politi Editore), p.61–97

Tupitsyn M., *Sots art, the new museum of contemporary art*, (New York : New Museum of Contemporary Art, 1986)

Weinstein, A (ed.), *Vitaly Komar: Three-Day Weekend*, (New York, The Humanities Gallery The Cooper Union for the Advanement of Science and Art, 2005)

Wollen, P., 'Painting History' in *Komar and Melamid*, (Edinburgh: The Fruitpickers Gallery, 1985)

Wollen P., 'Scenes from the Future: Komar and Melamid' in *Between Spring and Summer Soviet Conceptual Art in the Era of Late Communism*, (The Institute of Contemporary Arts, 1990), p. 107–119

Wollen, P., 'Morbid Symptoms: Komar and Melamid' in Wollen, P. *Raiding the icebox: reflections on twentieth-century culture*, (London: Verso, 1993),

Brooklyn Museum Archives (News Articles)

Grand Lobby Installation at Brooklyn Museum, Antiques & Collectibles, April 3-16, 1990.

Larson, Kay, *The Brooklyn Museum Iconoclasts*, April 30, 1990.

Navarra, Tova, *Soviet art timely, comprehensive and in area galleries*, Asbury Park Press, Feb 10, 1990.

Silverman, Diana, *Community Board Six: NIX on RED PIX!*, Our Town, 44, Feb 25, 1990.

Tallmer, Jerry, *Irreverence, Russian style*, New York Post, March 23, 1990.

Yalta 1945 on Display, The Phoenix, March 15, 1990.

News Articles

Bowlt, John E., *New Russian Wave*, Art in America 70, no. 4, April 1982.

Gambrell, Jamey, *Komar and Melamid: From Behind the Ironical Curtain*, Artforum 20, no. 8, April 1982.

Glueck, Grace, *Art Smuggled Out of Russia Makes Satiric Show Here*, The New York Times, Feb 1976.

Hillings V., *Komar and Melamid's Dialogue with (Art) History*, Art Journal, Winter 1999, Vol.58(4).

Hughes, Robert, *Through the Ironic Curtain*, Time, Oct 1982.

Indiana, Gary, *Komar and Melamid Confidential*, Art in America 73, no. 5, June 1985.

Kramer, Hilton, *Underground Soviet Art: A Politicized Pop Style*, The New York Times, Sept 1974.

Larson, Kay, *Kidding the Kremlin*, New York Magazine, Oct 1982.

Lerman, Ora, *Soviet Artists Make Open Form as Escape Route in a Closed Society*, Arts 58, no. 6, Feb 1984.

Levin, Kim, *Artful Dodges*, Village Voice, Feb 1984.

Woodward R., *Nobody's Fools*, Art News, Nov 1987.

Online Articles

Leigh-Perlman, Allison, *Future Ruins: Time, Memory and History in the Work of Komar and Melamid*, http://www.pitt.edu/~slavic/sisc/SISC8/docs/leigh-perlman.pdf, August 2009.

Musleah, Rahel, *The Arts: Freedom and Exile*, http://www.hadassahmagazine.org/2007/04/12/arts-freedom-exile/, April 2007.

Wilson, Sarah, *Moscow Romantic Exceptionalism: The Suspension of Disbelief*, e-flux journal #29, Nov 2011.

Websites

Brooklyn Museum, *Komar and Melamid: Yalta 1945 & Winter in Moscow 1977*, https://www.brooklynmuseum.org/opencollection/exhibitions/1154, 2016.

documenta, *documenta 8*, http://www.documenta.de/en/retrospective/documenta_8, 2016.

documenta archive, *documenta 8*, http://www.documentaarchiv.de/en/documenta/documenta-8.htmlenta 8, 2016

Komar, V., *Soviet Pop Artist Komar on His Work and Inspirations*, http://www.sothebys.com/en/news-video/blogs/all-blogs/notes-from-underground/2016/05/soviet-pop-artist-komar-interview.html, 2016.

Komar and Melamid, *chronology*, http://www.komarandmelamid.org, 2016.

Ronald Feldman Fine Arts, *Komar and Melamid*, http://www.feldmangallery.com/pages/home_frame.html, 2016.

Storefront for Art and Architecture, *Between War and Peace*, http://storefrontnews.org/archive/1990s/between-war-and-peace/, 2016.

Tate, *Artist interview: Vitaly Komar and Alexander Melamid*, http://www.tate.org.uk/whats-on/tate-modern/exhibition/ey-exhibition-world-goes-pop/artist-interview/vitaly-komar-and-alexander-melamid, Sep 2015.

Ben Uri: Short History and Mission Statement – Art, Identity and Migration

Ben Uri, 'The Art Museum for Everyone,' focuses distinctively on Art, Identity and Migration across all migrant communities to London since the turn of the twentieth century. It engages the broadest possible audience through its exhibitions and learning programmes. The museum was founded on 1 July 1915 by the Russian émigré artist Lazar Berson at Gradel's Restaurant, Whitechapel, in London's East End.

The name, 'The Jewish National Decorative Art Association (London), "Ben Ouri"', echoed that of legendary biblical craftsman Bezalel Ben Uri, the creator of the tabernacle in the Temple of Jerusalem. It also reflects a kinship with the ideals of the famous Bezalel School of Arts and Crafts founded in Jerusalem nine years earlier in 1906.

Ben Uri's philosophy is based on our conviction that fostering easy access to art and creativity at every level can add weight to our two guiding principles: 'The Dignity of Difference' and 'The Equality of Citizenship'. Ben Uri connects with over 300,000 people a year via its various creative platforms.

The museum positively and imaginatively demonstrates its value as a robust and unique bridge between the cultural, religious, political differences and beliefs of fellow British citizens.

Our positioning of migrant artists from different communities in London within the artistic and historical, rather than religious or ethnic context of the British national heritage is both key and distinctive. Through the generous support of our 'Preferred Partner' Manya Igel Fine Arts, we provide free entry to all our exhibitions, removing all barriers to entry and participation.

Ben Uri offers the widest access to all its extensive programming and physical and virtual resources including exhibitions, publications, website and outreach through:

● The permanent collection: comprising 1300 works, the collection is dominated by the work of first and second generation émigré artists and is supported by a growing group of emerging contemporary artists who will be a principal attraction in the generations to come. The largest collection of its kind in the world, it can be accessed physically via continued exhibition, research, conservation and acquisitions, or virtually.

● Temporary exhibitions: curating, touring and hosting important internationally focused exhibitions of the widest artistic appeal which, without the museum's focus, would not be seen in the UK or abroad.

● Publications: commissioning new academic research on artists and their historical context to enhance the museum's exhibitions and visitor experience.

● Library and archive: a resource dating from the turn of the twentieth century, documenting and tracing in parallel the artistic and social development of both Ben Uri and Jewish artists, who were working or exhibiting in Britain, as part of the evolving British historical landscape.

● Education and community learning: for adults and students through symposia, lectures, curatorial tours and publications.

● Schools: Ben Uri's nationally available 'Art in the Open' programme via the 'National Education Network' and 'The London Grid for Learning' is available on demand to c20,000 schools across the United Kingdom. Focus related visits, afterschool art clubs, family art days and competitions are also regular features.

● Artists: regular artists' peer group programmes, international competitions, guidance and affiliation benefits.

• Wellbeing: a pioneering set of three initiatives addressing the elderly who may be living in some isolation or with early stages of dementia. The programmes recognise the significant importance of the carer within the relationship and uses art practice as an effective bridge for positive engagement.

• Website: provides an online educational and access tool, to function as a virtual gallery and reference resource for students, scholars and collectors, and institutions.

Only then will the museum be able to fulfil its potential and impact on the largest audiences from the widest communities from home and abroad.

We see our future as pioneering a new form of visitor engagement in the museum sector. We will share our space with other émigré communities who will tell their own stories of journeys and life in London in modern times, and show their artists within a regular changing presentation. This new platform for emerging communities and artists will sit alongside, and as a key part of, the traditional museum matrix of collection, archive, exhibition, scholarship, learning and wellbeing designed to allow many different voices to attract, engage and stimulate large and diverse audiences from near and far.

Komar and Melamid

The Big Bang, 2004

Watercolour and pastel on paper

Courtesy of the Ben Uri Collection